TEZUKA SCHOOL of ANIMATION

Vol. 1 Learning the Basics

by Tezuka Productions

DIGITAL MANGA PUBLISHING

Carson

Contents

Translation
Jason D. DeAngelis

Design & Production
Fred Lui

Design Assistant
Matt Akuginow

Editing Assistant
Trisha Kunimoto

Lead Editing
Fred Lui

Publisher
Hikaru Sasahara

With Special Thanks to:
Mr. Minoru Kotoku

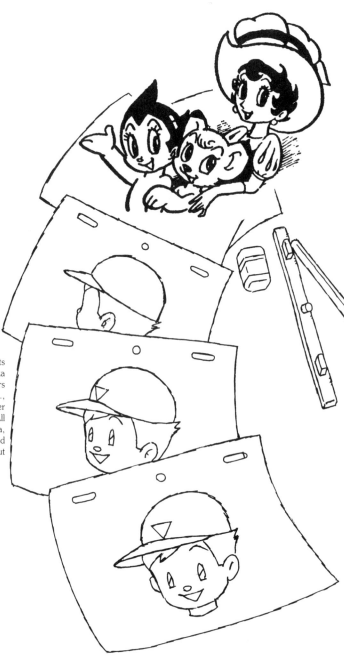

**TEZUKA SCHOOL OF ANIMATION
Vol.1 Learning the Basics**
Original Title: *Astro Boy's Animation Class.*

English Edition Published by
DIGITAL MANGA PUBLISHING
1123 Dominguez Street, Unit K
Carson, CA 90746
www.emanga.com

Distributed Exclusively by
WATSON-GUPTILL PUBLICATIONS
a division of VNU Business Media
770 Broadway, New York, NY 10003
www.watsonguptill.com

ISBN: 1-56970-995-5
Library of Congress Control Number: 2003095710
First Edition September 2003
10 9 8 7 6 5 4 3 2
Printed in Canada

Preface

Until now, numerous animation technique manuals have been published, written by assorted veterans of the animation world. Each one has been valuable in its own right, but they were all somewhat advanced, geared towards the intermediate animator or above. Up till now, there hasn't been an easy-to-understand, visual-based book that focuses on the needs of the true beginner, novice, or amateur.

This book, first and foremost, carefully explains the introductory aspects and principles of how objects move. You will learn step by step how to create smooth and dynamic animation, as well as the techniques to make an image "flow."

Nowadays, the animation world has seen remarkable technological advances, from the introduction of CG (computer graphics) to advancements in calculated timing and photographic technique. The basics, however, remain the same. Hand drawn frames, whether on cel or computer, are the foundation of all animation

Overall, the contents of this book only skim the surface of the animation world, but it should suffice as an easy-to-understand basic text, particularly for beginners.

In the animation world, even though you may start with one path, there are many other things to learn besides what's included in this book. But in the meantime, let's start learning the fundamentals of how to make pictures move, so you can breathe life into your own characters.

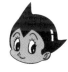 *Tezuka Productions, Animation Department*
http://www.tezuka.co.jp/

Chapter 1

The Basic Knowledge of Animation

Before you start to draw anime, there are few important points that you need to know first:

How to Create Animated Drawings
How to Draw Breakdowns and Breakdown lines
The Elements of Movement
Fundamentals of Movement

How to Create Animated Drawings

The creation of animated drawings is at present divided into two stages, as shown below.

Figure 1 (Example of key drawings)

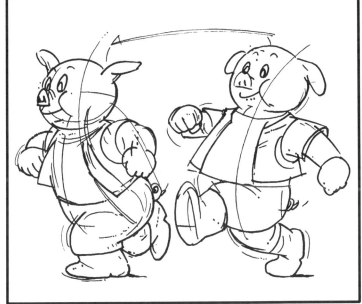

(1) Draw the key drawings

First off, draw only the poses that form the main points along the line of action. Also, pay attention to the timing of the movement.

Figure 2 (Example of breakdown drawings)

Second breakdown First breakdown

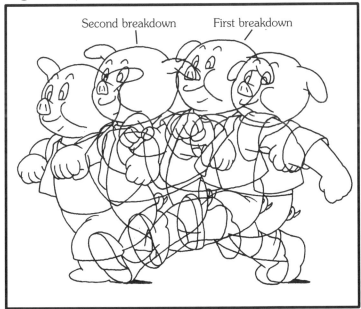

(2) Fill in the breakdown drawings

Put the finishing touches on the movement by drawing poses that fit in between the key drawings. Movement should look as natural as possible. You can think of breakdown drawings in terms of two stages: First breakdown and second breakdown.

How to Draw Breakdowns

Breakdown drawings are also referred to as "in-betweens." There are two ways of looking at in-betweens, as shown below.

Figure 3 (Mechanical in-betweens)

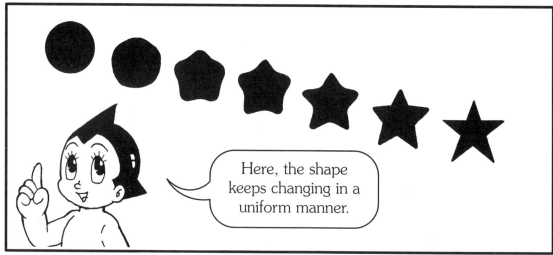

Breakdown drawings of a changing shape fill the space between key poses precisely and mechanically.

Figure 4 (Creative in-betweens)

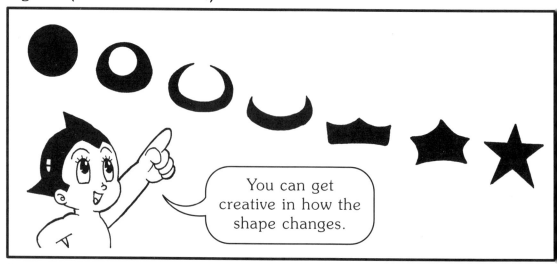

You can make creative in-between drawings that bear in mind the shape, material and nature of the moving object. Generally, this kind of creative inbetween work is preferred in animation.

How to Draw Breakdown Lines

A special technique is necessary to draw the lines of breakdowns. Usually, when making a breakdown drawing, you can start by making a clean copy of the key drawing. Since the key drawing is in rough form, complete the breakdown drawing by tidying up the picture into separate, clean lines, creating a finished product.

Figure 5 Key drawing (rough sketch)

Choose the appropriate lines and make a clean copy.

**Figure 6 Breakdown drawing
(A clean copy of the key drawing in Figure 5.)**

To do this, you've got to really understand the intention of the key drawing, in addition to having good enough technique so you don't lose the flavor of the key drawing.

What you need in your technique is the ability to show the feel and shape of the object, clearly and accurately.

Also, you need to know which lines to use and which not to use. This is a very important point in making breakdown drawings, so it's important that you really master this skill.

- Thick lines---Used for outlining and for emphasis.
- Medium lines---Used for areas adjoining the outline.
- Fine lines---Used for eyelashes, rims of the eyes, wrinkles in clothing, etc.

Distinguish when to use these three types of lines depending on your purpose.

Figure 7 (Example of not distinguishing between different types of lines)

Figure 8 (Example of distinguishing between different types of lines)

Also, be sure to make a distinction between the way a line stops (and starts).

A gradual stop. A sudden stop.

Obviously, it's no good if the lines are messy, broken, sticking out, or visibly intersecting.

You see, if you don't make a distinction between line types, a facial expression can look stiff and have an inorganic feel to it. But I'm sure you can see how dynamic it looks when you make a distinction between lines.

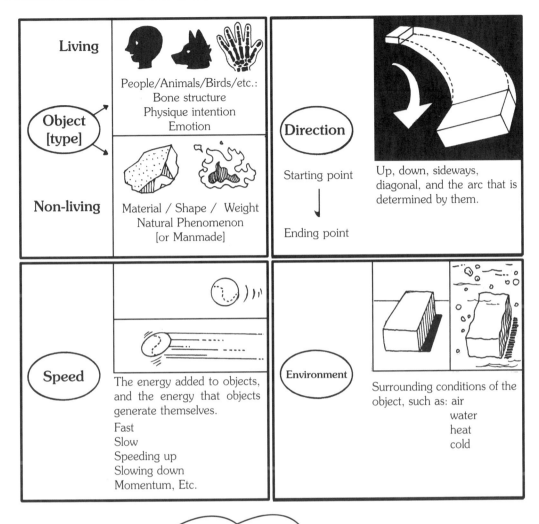

Living	People/Animals/Birds/etc.: Bone structure Physique intention Emotion	**Direction** — Up, down, sideways, diagonal, and the arc that is determined by them. Starting point ↓ Ending point
Object [type]		
Non-living	Material / Shape / Weight Natural Phenomenon [or Manmade]	

Speed — The energy added to objects, and the energy that objects generate themselves.
Fast
Slow
Speeding up
Slowing down
Momentum, Etc.

Environment — Surrounding conditions of the object, such as: air
water
heat
cold

The elements of movement can be divided into the four general categories above.

Movement is affected by these combined elements. An animator, always seeking to create better animation, should never fail to consider these factors.

Now, beginning with the next page, let's move on to specifics and learn about the "Fundamentals of Movement."

Fundamentals of Movement

Before actually learning about movement, let's take a look at the following.

Fundamentals of Movement
- Arc -

When objects move, the path that they follow is called an "arc."

- An arc should be depicted so that it conforms to a constant principle of uniformity.
- An arc without uniformity results in a jerky, awkward motion, lacking in continuity.

Figure 9 Pendulum swing: bad example that ignores an arc

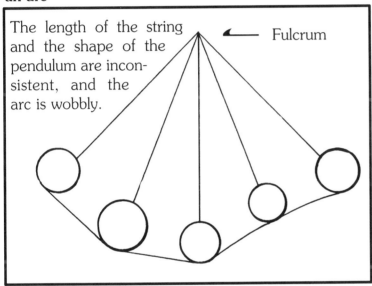

The length of the string and the shape of the pendulum are inconsistent, and the arc is wobbly.

Fulcrum

Figure 10 Pendulum swing: good example

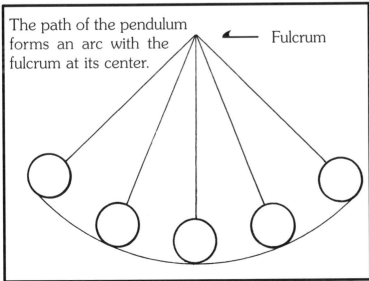

The path of the pendulum forms an arc with the fulcrum at its center.

Fulcrum

An animator must grasp the principle of uniformity for moving objects.

You've got to place moving objects along the proper arc.

You won't be able to make a proper arc if the size or shape of moving objects is irregular.

Fundamentals of Movement
- Speed Distribution -

When objects move, they don't always necessarily stay at a fixed speed.

Figure 11 Rolling a ball by hand.

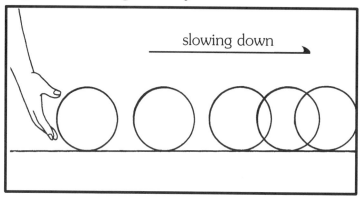

slowing down

It is necessary to adjus[t] acceleration and deceler[e]ation according to th[e] circumstance.

Speed adjustments shoul[d] not be made arbitrarily but should be based o[n] sound physical principles.

Figure 12 Start of car motion ⟶ stop

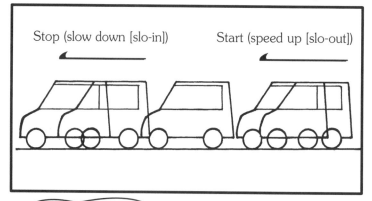

Stop (slow down [slo-in]) Start (speed up [slo-out])

Figure 13 Falling ball

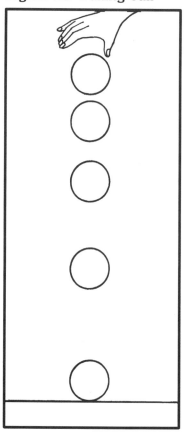

The distance that an object moves is proportionate to the time squared.

In the example of a falling ball, the ball is affected by gravity and picks up speed.

A rolling ball, however, slows down due to friction from the ground and will eventually stop, as in Figure 11.

Therefore, when you animate, make sure to adhere to the principle that when objects move, their speed is not constant.

In Figure 12, the car starts to move slowly, and is fastest at the midpoint, with the movement slowing down again at the end.

This is particularly the case when a moving object has its own driving force such as a car. That's because the Law of Inertia is at work.

Figure 14 "Cushioning" chart from end to end

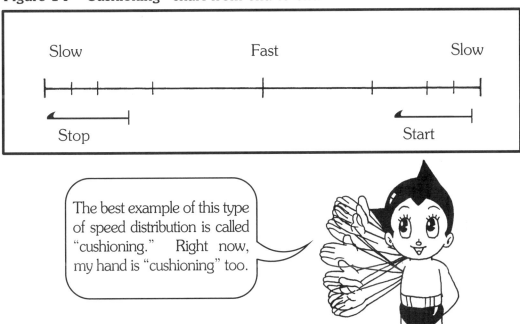

Figure 15 Speed distribution of a car.

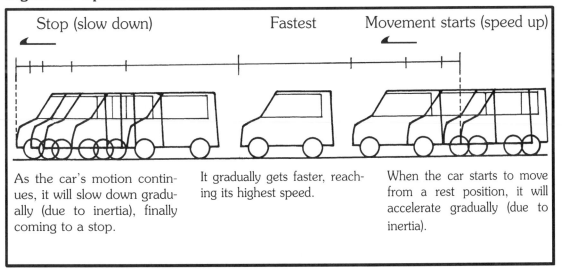

Stop (slow down)	Fastest	Movement starts (speed up)
As the car's motion continues, it will slow down gradually (due to inertia), finally coming to a stop.	It gradually gets faster, reaching its highest speed.	When the car starts to move from a rest position, it will accelerate gradually (due to inertia).

Fundamentals of Movement
- Squash and Stretch -

During movement, the energy affecting an object can often cause it to change it appearance. The change in appearance can be classified into two categories: squas and stretch. These are phenomena that actually occur in nature, but in animation, yo can increase their effectiveness by distorting the shape even more exaggeratedly.

Figure 16 A bouncing ball

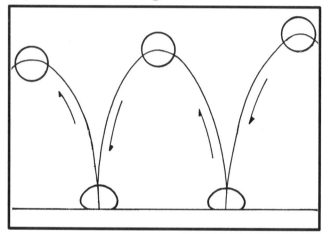

•Bounce can be thought of a divided into three stages:falling
 contact
 rising

•The arc of the bouncing ba depicts a "parabola."

• When bouncing, the ball speeds up when it falls and slows down when it rises.

• Because the speeding ball hits the ground forcefully, its shape changes, becoming squashed. This phenomenon is known as "squash."

• Squash and stretch are used to depict objects that have elasticity.

Figure 17 The moment "squash" occurs.

The direction in which the energy is going.

You can also use squash for comedic takes like this.

Figure 18 The moment when "stretch" occurs.

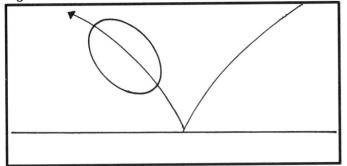

Figure 19 During stretch, make sure the volume of the ball is constant and the ball's orientation remains consistent.

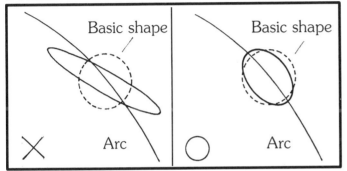

Figure 20 Similarly, during squash, the volume of the ball should not change.

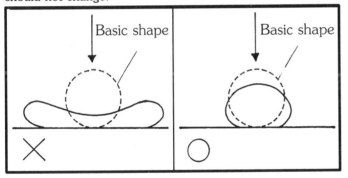

• After impact, the ball bounces up, and in that instant it changes shape, extending out vertically. This is called "stretch."

• It is more effective to use squash and stretch momentarily during movement.

• If you use them more than necessary, objects will appear to have an overly sticky or fluid consistency.

• You can get interesting results when applying squash and stretch to human or other movement.

Figure 21 Example of applying squash and stretch to humans

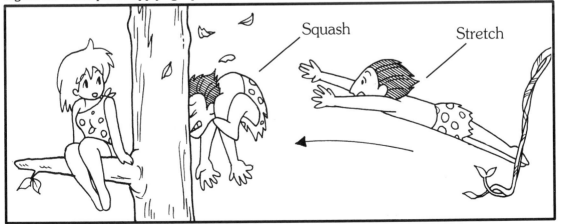

Fundamentals of Movement
- Delay -

Depending on the material of a moving object, all parts will not necessarily move at the same time. This is referred to as "delay."

• When a soft object moves, such as the elephant's trunk in figure 22, the object will appear stiff if everything moves at once.

• Let's consider the concept of "energy transmission."

• The energy that moves the elephant's trunk originates in the muscular power at the base of the trunk and is gradually transmitted to the middle of the trunk and finally reaches the outermost tip.

• Therefore, when the base of the elephant's trunk starts to move, the tip of the trunk should not be moving yet.

• As a result, the elephant's trunk takes on a smooth, wavy appearance.

• This lagging movement of the tip is a concrete example of "delay."

Figure 22 Bad example of an elephant's trunk where the entire trunk moves simultaneously.

Figure 23 Good example.

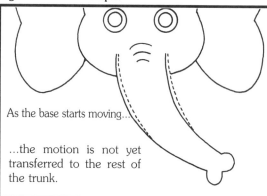

As the base starts moving...

...the motion is not yet transferred to the rest of the trunk.

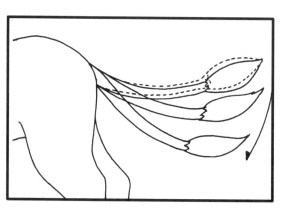

"Delay" is a phenomenon that can also be seen in the movement of animals' tails, like in the illustration to the left. In contrast to the base of the tail, the tip of the tail moves later. This also occurs for a fish's tail fin and for inanimate cloth-like objects, such as flags or capes.

Why the Principle of "Delay" Occurs

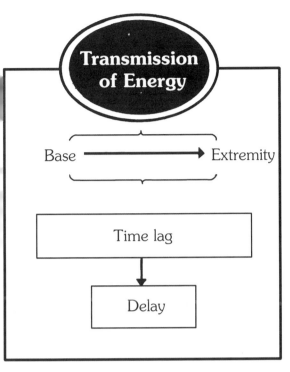

Figure 24 Specific examples of "Delay" (1)

Figure 25 Specific examples of "Delay" (2)

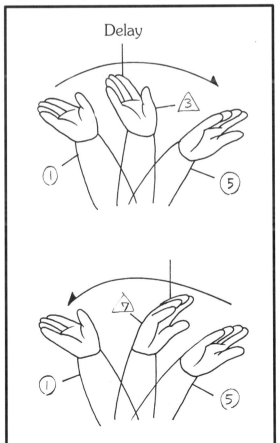

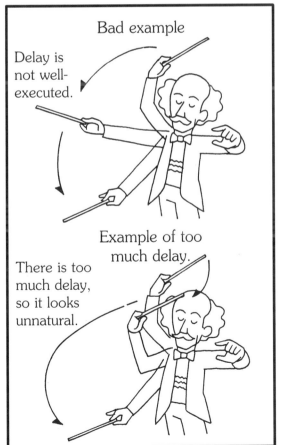

17

Fundamentals of Movement
- Anticipation -

Human movement, depending on the context, can be divided into a "preparator[y] action" and a "main action." The "preparatory action" is also known as "anticipation."

Figure 26 Lowering a hoe
A weak pose with no energy.

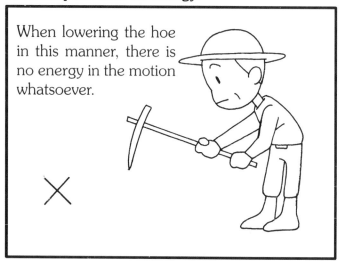

When lowering the hoe in this manner, there is no energy in the motion whatsoever.

• A person tilling a field will no[t] be able to till well if he lower[s] the hoe in this manner. That['s] because it is a weak movemen[t] lacking energy.

•In the actual movement, there['s] always an initial motion in whic[h] the hoe is momentarily swun[g] upwards. If not, the movemen[t] will lack power. That's wher[e] the "anticipation" comes in.

Figure 27 The hoe is swung up.
As a result, the motion becomes powerful.

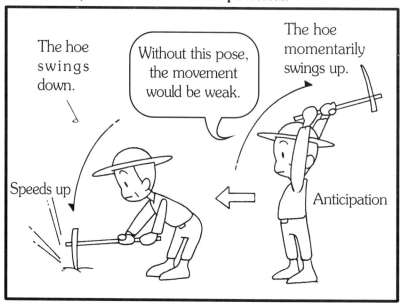

The hoe swings down.

Without this pose, the movement would be weak.

The hoe momentarily swings up.

Speeds up

Anticipation

There are lots of ways to apply this, but it can get tricky.

Fundamentals of Movement
- Joints -

Human movement is generated by the interconnected motion of various joints. It's important to gain an understanding of the workings of individual joints first and then apply it effectively to each motion.

Figure 28 Raising the arms

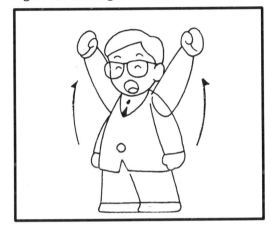

Figure 29 An inbetween that doesn't consider joint movement.

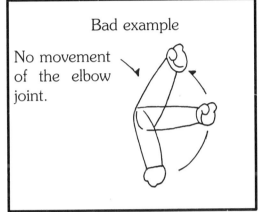

Bad example

No movement of the elbow joint.

Figure 30 Example of an inside arc

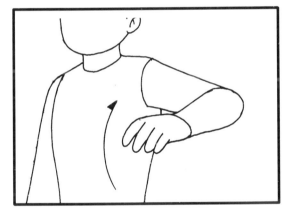

Figure 31 Example of a middle arc

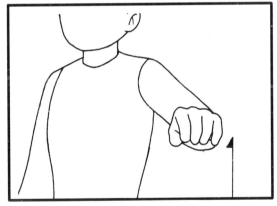

Figure 32 Example of an outside arc

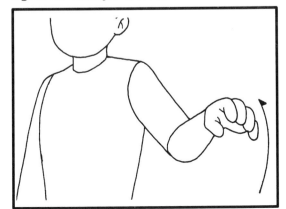

• The movement of joints is not uniform; many variations possible.

• For example, even for a motion like raising the arms in Figure 28, it can vary depending on whether you decide to use an outside, middle, or inside arc for the middle pose.

Figure 33 An example of movement that incorporates accurate joint-use (when grabbing an object).

A. Grabbing a stick

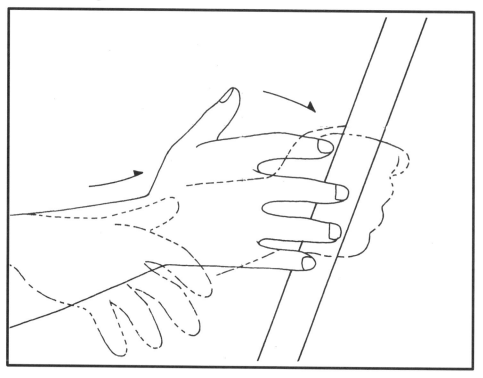

B. Grabbing a ball

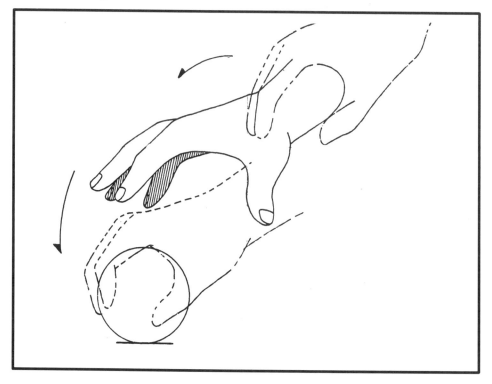

Fundamentals of Movement
- Transfer of Weight -

Figure 34 Standing up from a chair

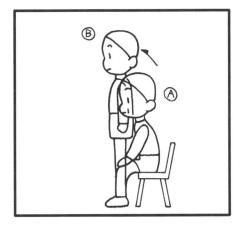

When depicting human movement, you have to figure out where to place the center of gravity. Drawings without a center of gravity appear unnatural and lack vitality. Make sure you draw the body so it won't fall, with the center of gravity always stable.

Figure 35 Example of an inbetween that ignores the center of gravity.

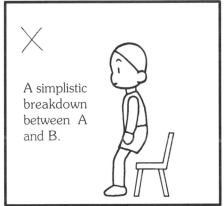

A simplistic breakdown between A and B.

For example, it looks unnatural if you draw the motion of standing up from a chair with a breakdown pose like the one in Figure 35. You can't possibly stand up from this posture.

Figure 36 Example of an inbetween that incorporates the center of gravity.

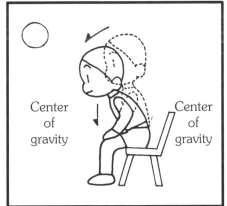

Center of gravity

Center of gravity

Actually, the best pose is the one in Figure 36, where the center of gravity is balanced.

Be aware that the center of gravity is constantly shifting during movement.

Standing up from a chair can't be done unless the upper half of the body leans forward briefly, like in this picture.

Figure 37 Lifting a mallet

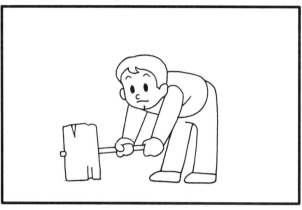

• Getting the center of gravity right means that you are sufficiently conveying the heaviness of an object.

• For example, when the mallet is lifted in Figure 38, the weight of the mallet is not sufficiently conveyed.

Figure 38 An unnatural pose that doesn't convey weight

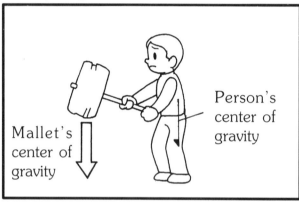

Mallet's center of gravity

Person's center of gravity

If you want to convey the weight of a mallet, look at the movement in Figure 39.

Figure 39 Movement that incorporates the weight of the mallet

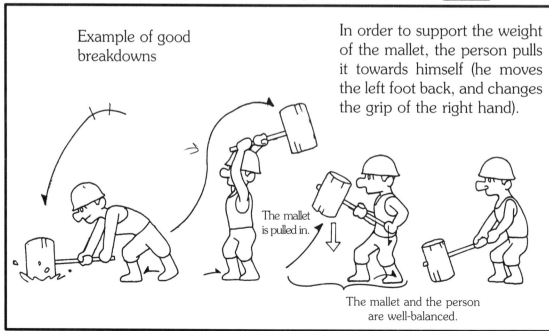

Example of good breakdowns

In order to support the weight of the mallet, the person pulls it towards himself (he moves the left foot back, and changes the grip of the right hand).

The mallet is pulled in.

The mallet and the person are well-balanced.

Fundamentals of Movement
- Drag -

During movement, there are times when you have to consider both a "main object" and a "subordinate object." Scarves, capes, or a woman's long hair would apply to the latter.

Figure 40 Objects that drag

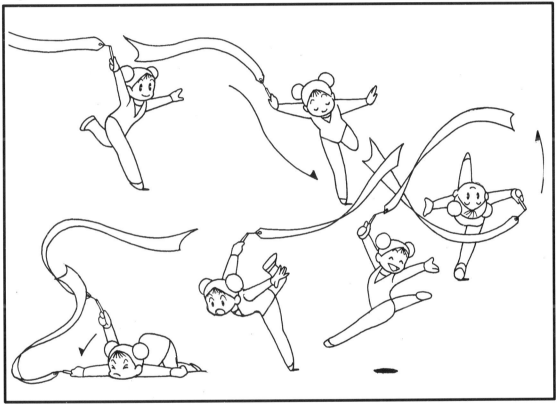

Make sure that the movement of the ribbon is always dragging behind the girl. This "timing gap" creates an all the more cartoon-like movement.

• If the scarf or cape moves at the same time as the character, it doesn't feel right. There should always be a gap in the timing.

• The movement of the object itself comes first, and then the scarf should or cape move in a subordinate fashion. They should always follow one beat later than the movement of the main object.

Figure 41 Examples of objects that drag (holding a handkerchief)

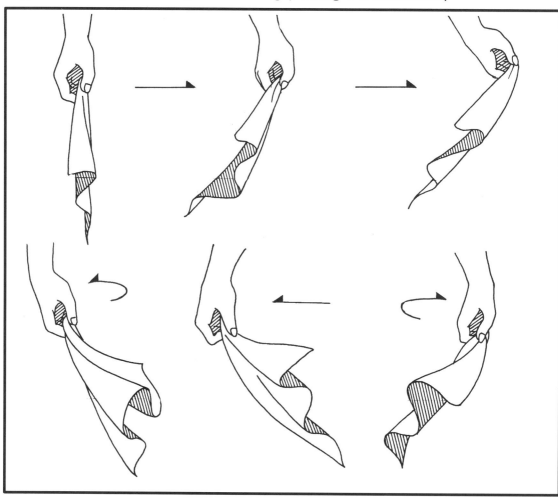

Figure 42 The head of a girl who is running and then stops. (Her braid drags behind.)

In animation, this "timing gap" is a really important concept!

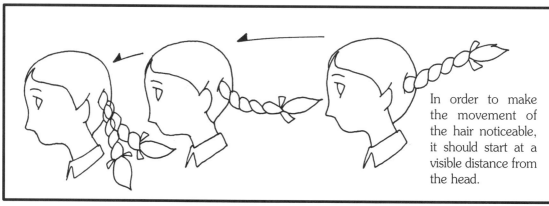

In order to make the movement of the hair noticeable, it should start at a visible distance from the head.

Fundamentals of Movement
- Reaction -

When a fast movement suddenly stops, the object goes a little past the original stopping position, due to inertia, and then returns. This is called reaction.

Figure 43 Finger-pointing motion (example showing extremes of motion)

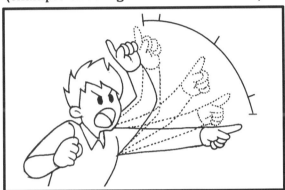

Figure 44 Finger-pointing motion (sped-up example)

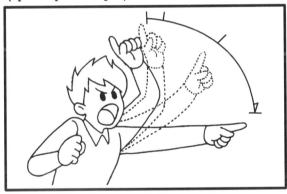

Figure 45 Finger-pointing motion (example that incorporates reaction)

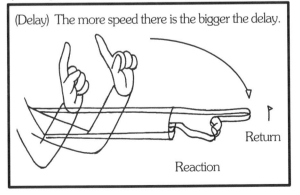

(Delay) The more speed there is the bigger the delay.

Return

Reaction

• For example, in a finger-pointing motion with fast timing, like in Figure 43, the speed is distributed evenly between the two extremes and it doesn't look at all realistic.

• But if you speed up the motion, it's much more effective.

• What's more, you can get an even better look if you incorporate a reaction, like in Figure 45.

• Reaction should not necessarily be assigned to all actions.

It's best to pick and choose when to use a reaction based on the purpose and outcome of a movement. The extent to which it is used should also be based on the style and the characters. Reaction is important for both realistic and cartoonish characters. However, the degree of exaggeration is something that should vary according to style.

Chapter 2
Real Movement
- People -

• Human action seen from a variety of perspectives

Among the various types of animation, there's mechanics, special effects, animals, and recently CG has also been added.

However, since most works center on human drama, human movement is of primary concern more than anything else.

Now let's take a look at some basic human movements, such as walking, running, and turning back.

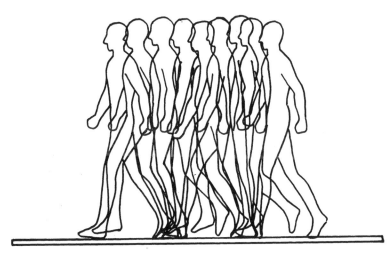

Things to keep in mind:

Relation between path of action and joints
Length of skeleton
Overall rough sketch

Real Movement
- Walking -

Walking is one of the most basic human activities and appears in animation frequently. It's a very important movement, so let's learn the proper mechanics of walking so that it will appear natural.

This is ——▶ a cartoonish walk.

Figure 46 Key drawings for a walk

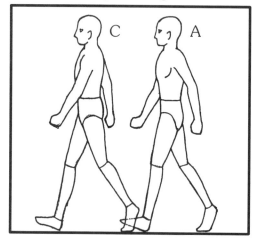

Figure 47 Initial inbetween pose

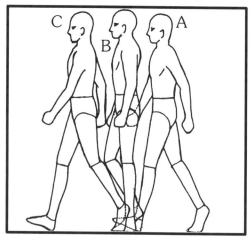

Figure 46 shows the key poses of a walk that are generally used in Japanese animation.

Start with the two key poses, switching the positions of the left and right hands and feet. Then proceed to draw the breakdown pose.

Usually, the sequence for filling in the inbetweens is to draw the B pose in the middle position first.

Then, after filling in two or three drawings between A and B, and between B and C, the walk will be completed.

When you draw the inbetweens, make sure that all the elements are uniform in size and length, including the rise and fall of the body, the distance traveled, and the movement and arc (path of action) of each joint. This may seem easy, but since there are so many points you need to handle with precision, it's actually quite challenging.

Naturally, the manner of walking will differ depending on whether it's a man, woman, child, elderly person, or even depending on the character's condition at the time.

Figure 48 Five inbetweens (shot in 2 or 3 frames)

The side-view walk is the foundation of all other walks.

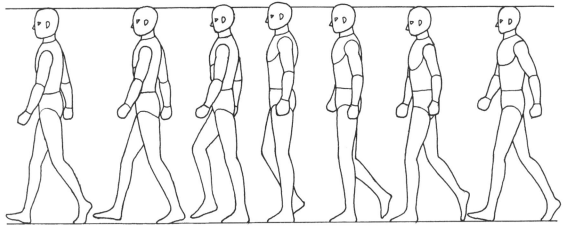

◄—— Movement of right leg

Figure 49 Three inbetweens (shot in 3 frames)

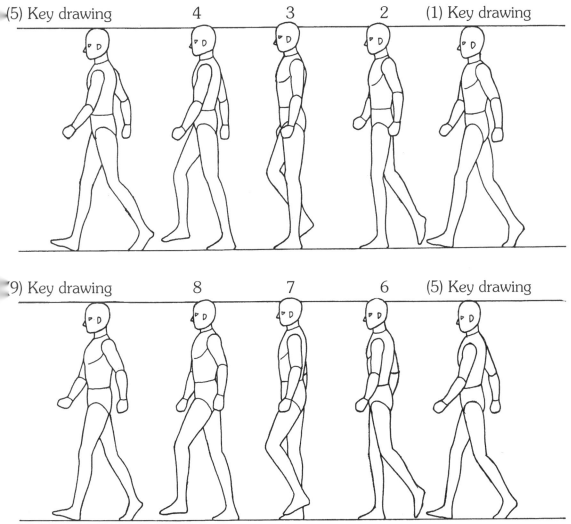

(5) Key drawing 4 3 2 (1) Key drawing

(9) Key drawing 8 7 6 (5) Key drawing

◄—— Movement of left leg

Figure 50 Filling in inbetweens with bobbing movements

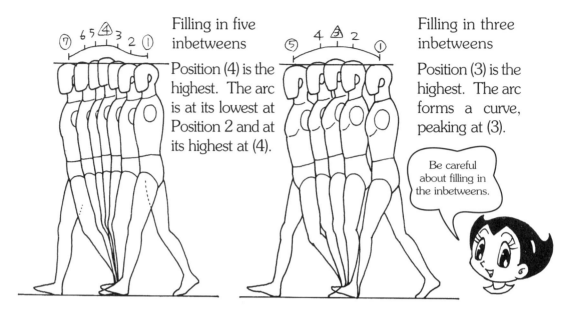

Filling in five inbetweens

Position (4) is the highest. The arc is at its lowest at Position 2 and at its highest at (4).

Filling in three inbetweens

Position (3) is the highest. The arc forms a curve, peaking at (3).

Be careful about filling in the inbetweens.

Figure 51 Walk from diagonal view

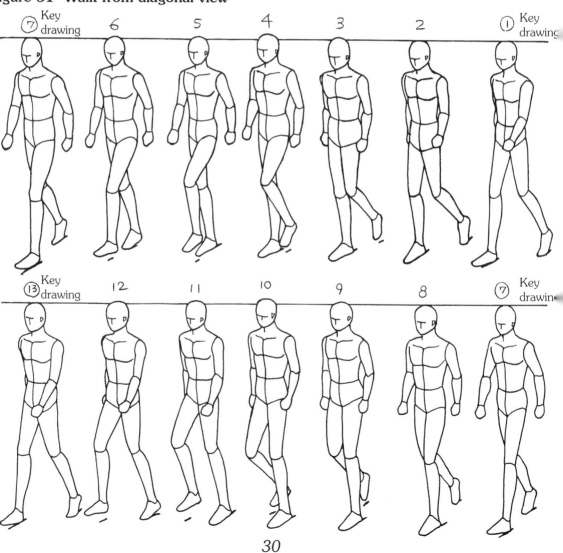

⑦ Key drawing 6 5 4 3 2 ① Key drawing

⑬ Key drawing 12 11 10 9 8 ⑦ Key drawing

Figure 52 Walk from rear diagonal view

Movement of left leg

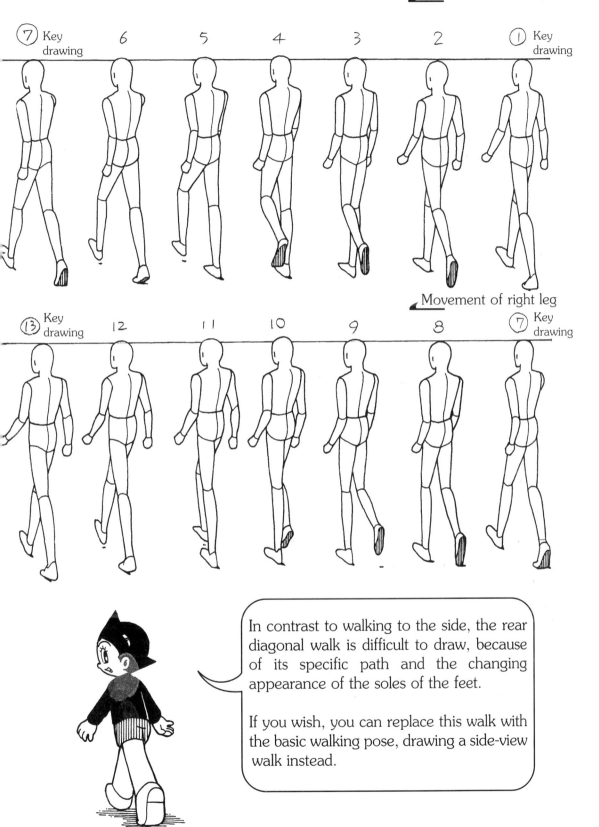

⑦ Key drawing 6 5 4 3 2 ① Key drawing

Movement of right leg

⑬ Key drawing 12 11 10 9 8 ⑦ Key drawing

In contrast to walking to the side, the rear diagonal walk is difficult to draw, because of its specific path and the changing appearance of the soles of the feet.

If you wish, you can replace this walk with the basic walking pose, drawing a side-view walk instead.

31

Figure 53 Rear-view walk

Movement of right le●

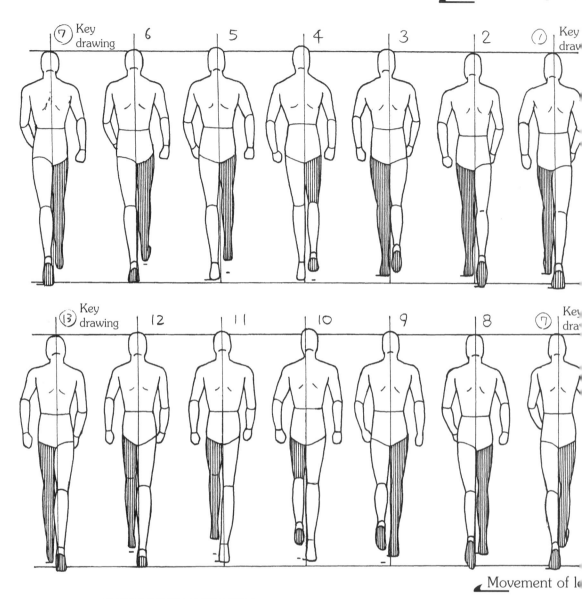

| ⑦ Key drawing | 6 | 5 | 4 | 3 | 2 | ① Key draw |

| ⑬ Key drawing | 12 | 11 | 10 | 9 | 8 | ⑦ Key dra● |

Movement of l●

The impression given is quite different for the rear-view walk than for the side-view or diagonal-view walk. Pay attention to the slight shifting from left to right of the shoulders and back. In a dramatic context, the rear-view walk is quite common.

Figure 54 Front-view walk

Movement of right leg

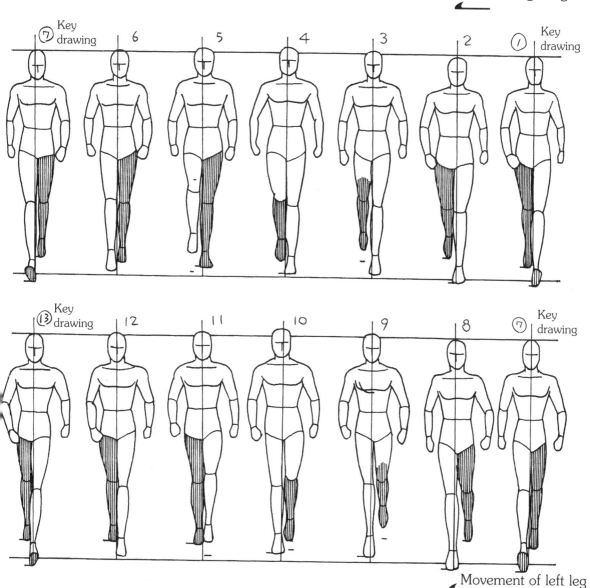

Key drawing ⑦ 6 5 4 3 2 ① Key drawing

Key drawing ⑬ 12 11 10 9 8 ⑦ Key drawing

Movement of left leg

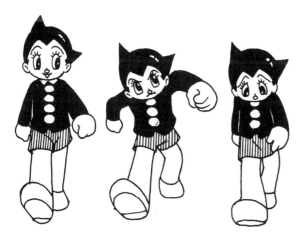

Even for the same front-view walk, there may be variations, like the ones to the left, based on the emotional state of the character. Naturally, the number of inbetweens and the timing may also change.

Figure 55 Bird's eye view walk

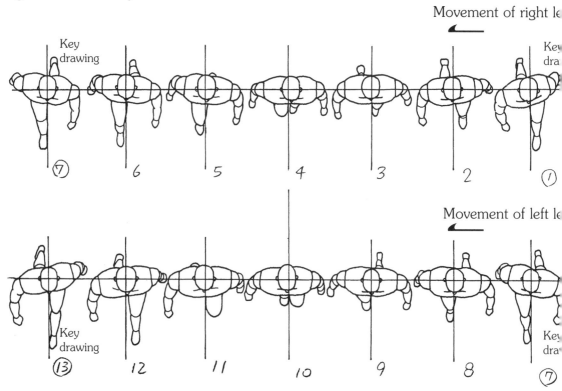

Up till now, we have shown you various walking patterns, but they're only the basic
Actual walking has various characteristics based on factors such as gender, body typ
occupation, age, psychological state and physical condition.

Real Movement
- Running -

Running is also a movement we see on a daily basis. Like walking, let's first learn the proper mechanics of running so we can create a natural movement.

Figure 56 Running breakdown Most basic run

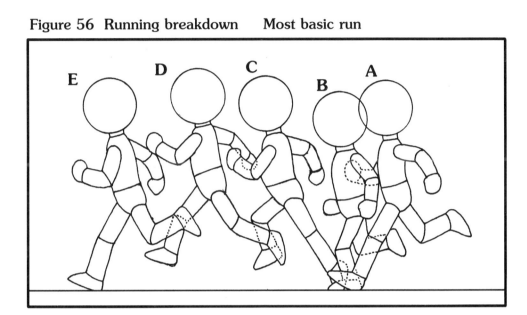

The crucial difference between running and walking is that with running there is a moment of floating when both feet are completely separated from the ground (figure 56).

Why does this moment occur? It's because in running, much more so than walking, there is a strong driving force.

In order to kick off the ground powerfully, a pose like C in Figure 56 is necessary to gather energy before the kick.

The airborne body lands on the ground with the front foot. That's pose A and E in Figure 56. Running is based on these repeating principles.

The driving force of the run is a result of powerfully kicking off of the ground. (Pose C, Figure. 56), This pose is extremely important for running.

There are many different kinds of runs, such as sprinting and jogging, but all of them are based on the basic pattern in Figure 56.

Figure 57 The basic principle of running

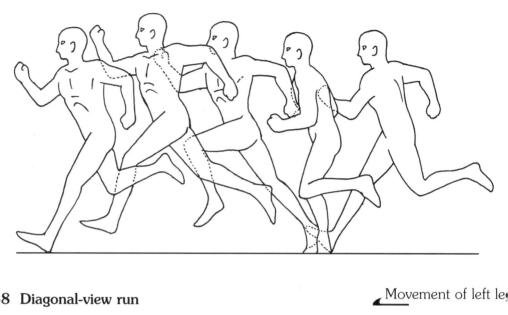

Figure 58 Diagonal-view run

Movement of left leg

⑤ Key drawing
4
3
2
① Key drawing

Movement of right leg

⑨ Key drawing
8
7
6
⑤ Key drawing

Refer to pg.54 to view a sample of this running technique by way of "page-by-page" flip animation.

36

Figure 59 Diagonal rear-view run

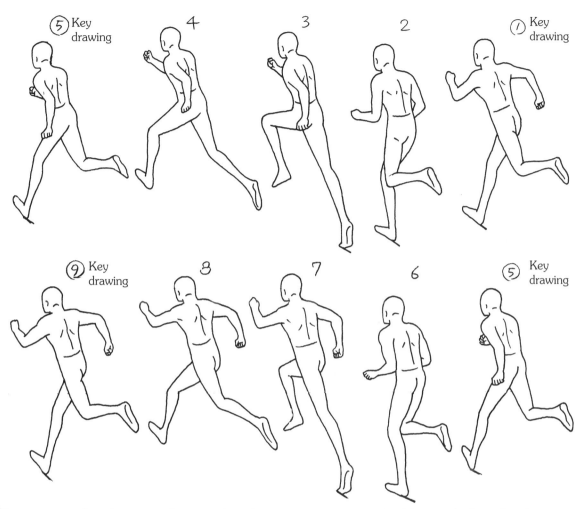

Please note that in poses four and eight, arm swing is at its biggest before landing on the ground.

Figure 60 Rear-view run

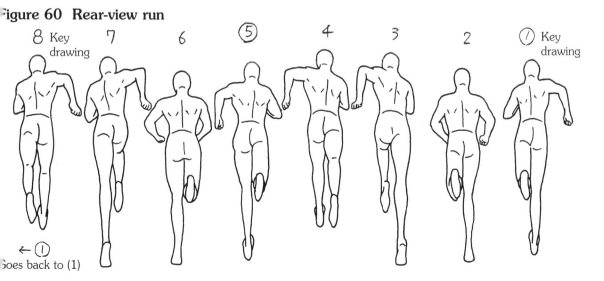

Goes back to (1)

37

Figure 61 Front-view run

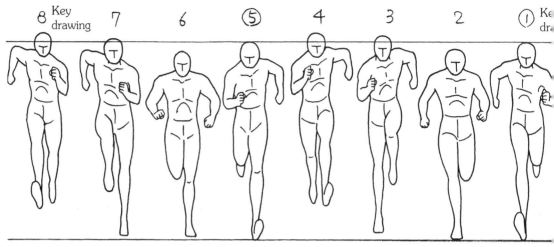

Figure 61 shows a running cycle of five drawings (if you shoot each drawing twice, i makes ten frames).

For faster running, four drawings would be one cycle. In that case, position four in the air would be left out.

Figure 62 Run

The camera follows the running character at the same speed.

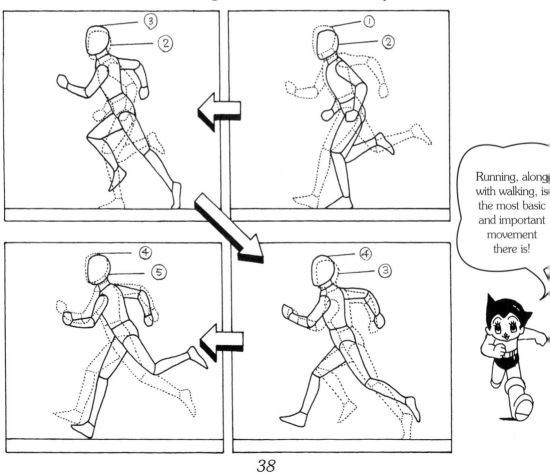

Running, along with walking, is the most basic and important movement there is!

Figure 63 Skips

Skipping is a unique motion that combines elements of both running and walking. In animation, it is a slightly complicated process so you don't see it very often. However, it's a rhythmical movement appropriate for the character of a little girl. Skipping is a repeating motion that probably would need four key drawings.

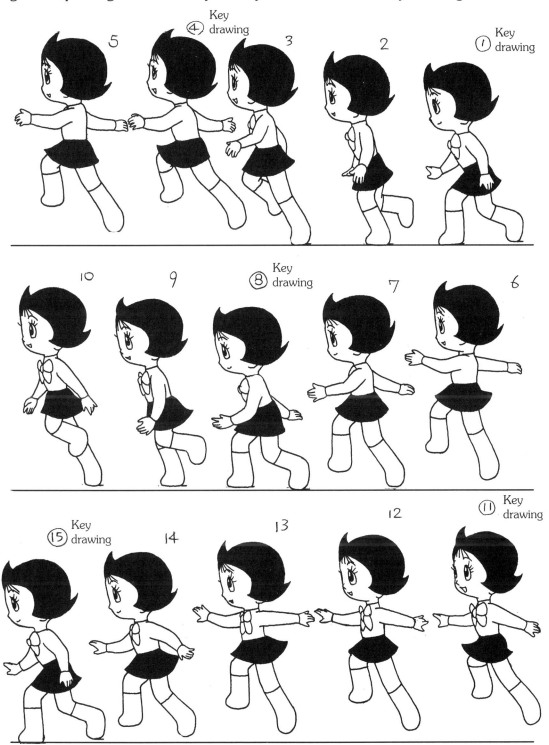

Refer to pg.53 for a sample of this skipping technique by way of a "page-by-page" flip animation.

Real Movement
- Head-Turns -

When depicting people turning their heads, it's necessary to be able to make an accurate sketch of the head. You need to understand the head in terms of its three dimensionality, and be able to draw it from any perspective.

Figure 64 Head angles

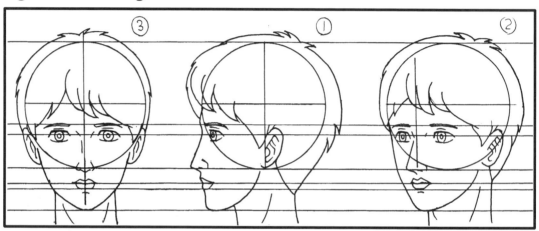

Figure 65 Perspective during head rotation

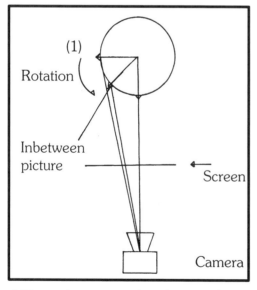

As in Figure 65, make sure that the head rotating at a seemingly uniform speed appears closer to (1) in its intermediate (inbetween) position, due to the perspective.

Figure 66 The head-turn and the distance between the eyes

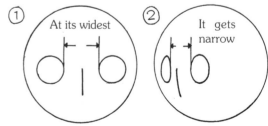

When drawing a head-turn, don't forget about the changing perspective.

When moving from the frontal view of (1) to the diagonal view at (2), the distance between the eyes becomes markedly narrow. Of course, you may at times see animation where this doesn't happen.

40

Figure 67 Example of a head-turn

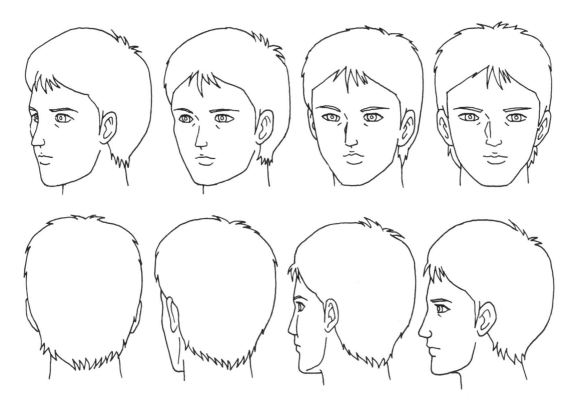

Figure 68 Downward gaze to upward gaze

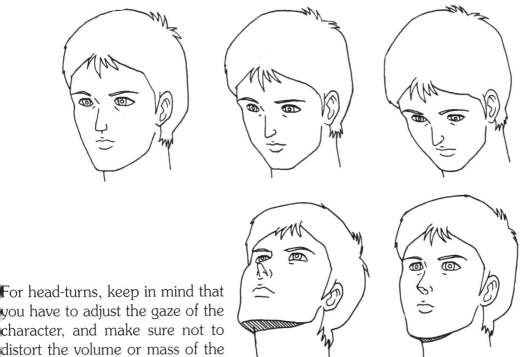

For head-turns, keep in mind that you have to adjust the gaze of the character, and make sure not to distort the volume or mass of the head.

41

Real Movement
- Standing Up -

There are also many different kinds of standing-up motions. To avoid unnatural movement, pay close attention to the center of gravity and to the use of the joints.

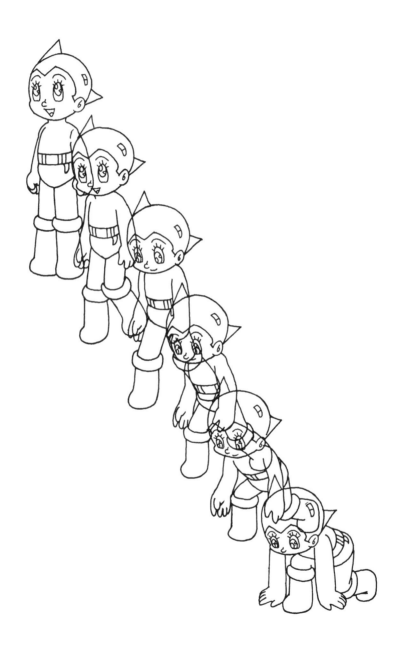

Figure 69 Stand-up from a crouching pose

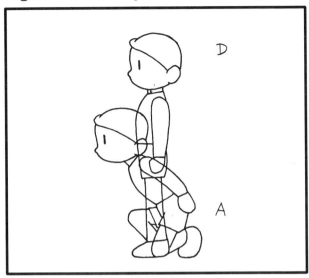

• It would be a mistake to draw an inbetween pose like B1 in Figure 71 for the breakdown of position A (on one knee) and position D (standing up). B1 is a mechanical inbetween and is merely a combination of poses A and D.

• Actually it should be more like Figure 70, with both B and C as necessary stages. Let's take a look at which joints move as a result of the shifting center of gravity.

Figure 70 Good in-between

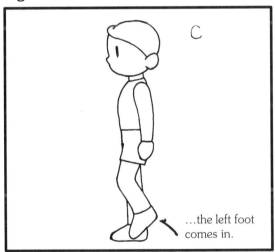

...the left foot comes in.

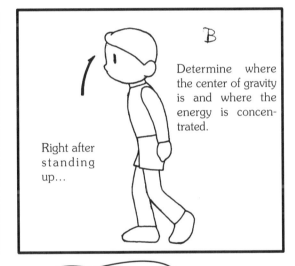

Determine where the center of gravity is and where the energy is concentrated.

Right after standing up...

Figure 71 Bad in-between

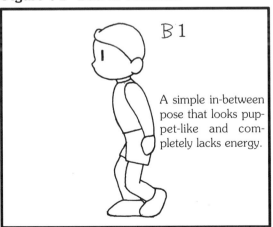

A simple in-between pose that looks puppet-like and completely lacks energy.

A good in-between is not a simple breakdown of picture to picture or line to line. It is a breakdown of movement to movement.

Real Movement
- Jumps -

You can't jump without an "anticipation." Before jumping, there's always a crouching pose (an anticipation) that's included.

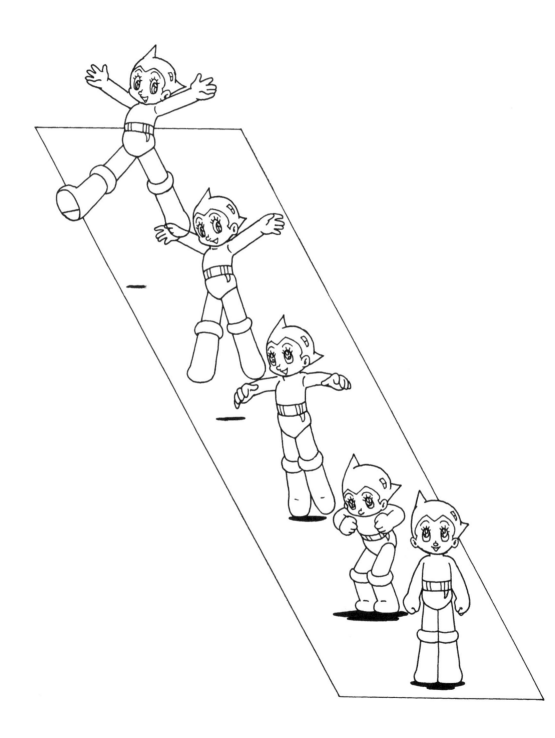

Figure 72 Hopping repetition

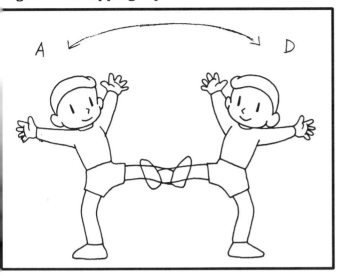

• You often see the repetition of movements A and D, as in Figure 72, but it is a mistake to draw the inbetween for them like B1, in Figure 74.

• Actually, the inbetween should be like B and C in Figure 73.
If not, the jumping movement will not look right.

Figure 73 Example of good inbetween

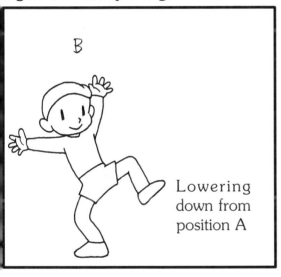

Lowering down from position A

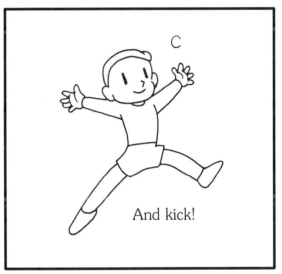

And kick!

Figure 74 Example of bad inbetween

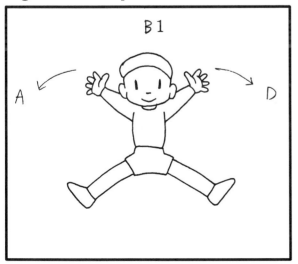

• Figure 73 shows the inbetween movements when moving from A to D.

When returning to A from D, there will be a lowering once again at D, followed by another kicking pose. Fill in E (lower) and F (kick), which are not pictured here, to complete the repeating cycle.

45

Real Movement
- Body-Twists -

"Twisting" is a movement often used in dramatic works. Make sure to gain an understanding of the human body from a three-dimensional perspective, and learn to sketch it properly.

Figure 75 A body-twist

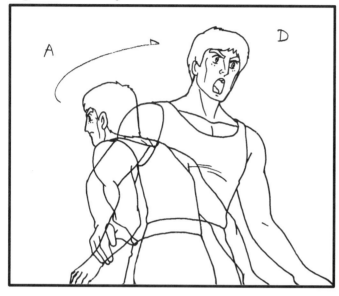

• When filling in the in-betwee of A and D, in Figure 75, i which the body twists in a broa movement, a mechanical in between like B1, in Figure 77 does not look good.

• Actually, it should be more lik B, in Figure 76. Please pa attention to the direction of th face and the position of th arms.

Figure 76 Example of good in-between

The face is already looking at its target.

The arms form a wide arc.

A wide arc creates a kinetic, powerful impression.

Figure 77 Example of bad in-between

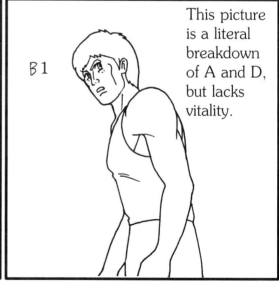

This picture is a literal breakdown of A and D, but lacks vitality.

This picture gives no impression whatsoever of agility. Instead, there's a sense of sluggishness and an overall lack of energy.

Real Movement
- Throwing -

Think of the motion of throwing an object as a full-body action. The motion of each joint works in unison to form a single integrated action.

Breaking down the throwing movement:
1) Hip rotation
2) Upper body rotation
3) Arm swing
4) Wrist snap

Rotational movement is generated by the rotating of the hips. The energy is then transmitted in sequence to the extremities of the body.

Figure 78 Throwing movement

Real Movement
- Kicking -

Figure 79 Kicking

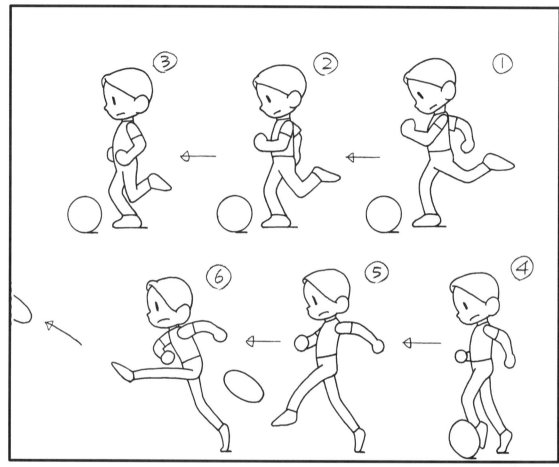

The kicking motion is also a full-body action. In order to focus the energy to the very tip of the foot, each part of the body works together efficiently as a unified whole. Make sure that the upper body and lower body are rotating in opposite directions.

Breaking down the kicking movement
(1) Hip Rotation
(2)~(3) Popping of the greater trochanter (outer hip bone)
(4) Extension of knee joint
(5) Snapping of ankle

The pivot leg supports the body's weight and generates power, while at the same time, the upper body twists in the opposite direction o the lower body in order to maintain balance.

Real Movement
- Blinking -

Figure 80 Blinking

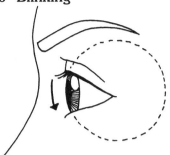

In order to draw blinking you must have a proper knowledge of anatomy.

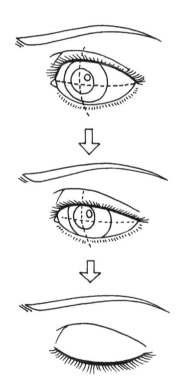

You can't draw blinking without a proper understanding of the human eye and its structure. This is true even for a distorted cartoonish character, whose blinking motion must also be based on a three-dimensional sketch.

The opening and shutting of the eyelid conform to the roundness of the eyeball.

For a cartoonish eye like Astro Boy's, the eyeball lowers a bit like in the middle picture.

The actual time it takes to blink is about 0.2 seconds, but for animation, it's probably better to have it at 0.3~0.5 seconds. Even for cartoonish characters, make sure that the blinking movement does not come across as two-dimensional.

Real Movement
- Opening and Closing the Mouth -

The movement of the mouth when speaking is, in Japanese animation, mostly show in an abbreviated fashioned. (Especially in TV animation.) When depicting the mout in more detail, mouth shapes that correspond to the different vowel sounds ar necessary.

Figure 81 Opening and closing the mouth

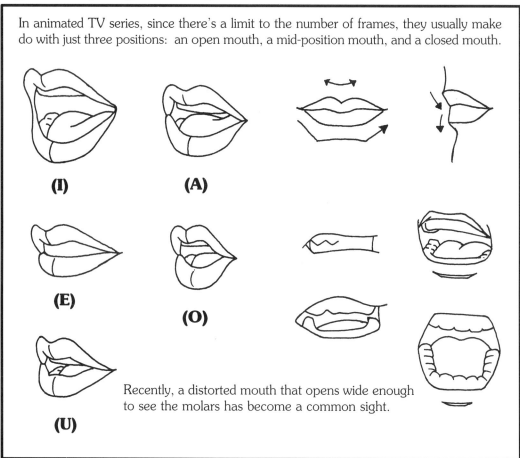

In animated TV series, since there's a limit to the number of frames, they usually make do with just three positions: an open mouth, a mid-position mouth, and a closed mouth.

(I) (A)

(E) (O)

(U)

Recently, a distorted mouth that opens wide enough to see the molars has become a common sight.

• You can't accurately draw the opening and closing of the mouth without first knowing how to sketch the human mouth in an anatomically correct fashion.
• This even applies to drawing distorted, cartoonish characters.
• The anatomy of the lips is even more complicated than you might think, as it is full of undulations. Draw the lips with precision, making sure that they are three-dimensional.
• There are exceptions for certain types of animation, such as commercials that may use extremely two-dimensional characters.

Sometimes, you also see comedic mouths like this.

50

Real Movement
- Multiple Characters -

> For movement involving multiple characters, you have to bear in mind the energy they are both using. That means you need to think about the movement for both characters.

Figure 82 Movement involving multiple characters

• In cases like Figure 82, the two characters show independent movements.

• However, in order to avoid being hit, there will probably be elements of evasive action in their movement.

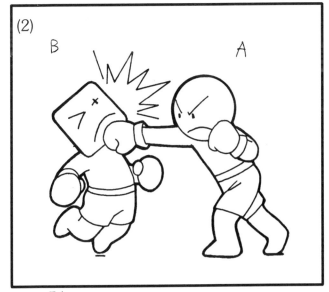

(1) Both of their movements are determined by each other.

B A

⇩

• (2) shows A hitting B. In this case, you shouldn't just put in a simplified breakdown of (1) and (2) as the inbetween for B's movement.

• If you end up making a normal inbetween, it will seem as if B has stuck out his face for the sole purpose of being hit by A.

• So, what should the picture look like in order to evoke a boxing-like motion?

(2)

B A

Figure 83 Obvious Inbetween

In this case, it looks like B is walking into the punch.

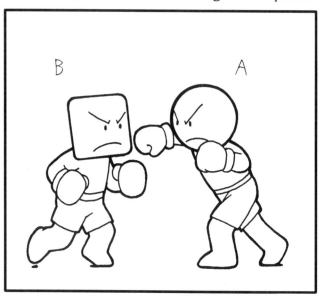

• B will continue to move to the last, trying to evade getting hit.

• However, ultimately, there must be the sense that B has been fully hit by A's punch.

• In this way, the movement of one character becomes forceably altered due to the movement of the other character.

• Be sure to remember that this is something that occurs frequently in scenes where multiple characters are moving.

• In addition, when one character hands something over to another character, or when two characters hug each other, you will unexpectedly run into problems if you don't consider the individual timing and movement of either character, so be careful.

Figure 84

(1) ⟶ (2) An inbetween where B is trying to evade the blow, but will ultimately get hit.

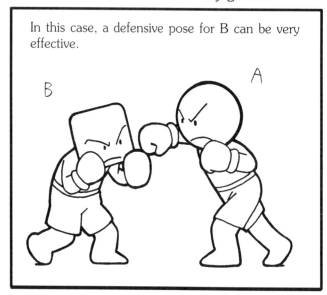

In this case, a defensive pose for B can be very effective.

For example, it's not shown here, but when there are two characters in the foreground and a referee in the background, there are three variations of movement to consider. In this way, animation can be very complex, but in the end all of it depends upon your own imagination.

Flip Animation Sample
- Character Skipping -
Flip the drawings to see animated movement!

• Look closely at this sample of flip animation taken from pg.39, fig.63. Flip the next few following pages back and forth to see how the movement is drawn and represented while this character is skipping.

• Flipping drawings back and forth is how animators test-sample their work.

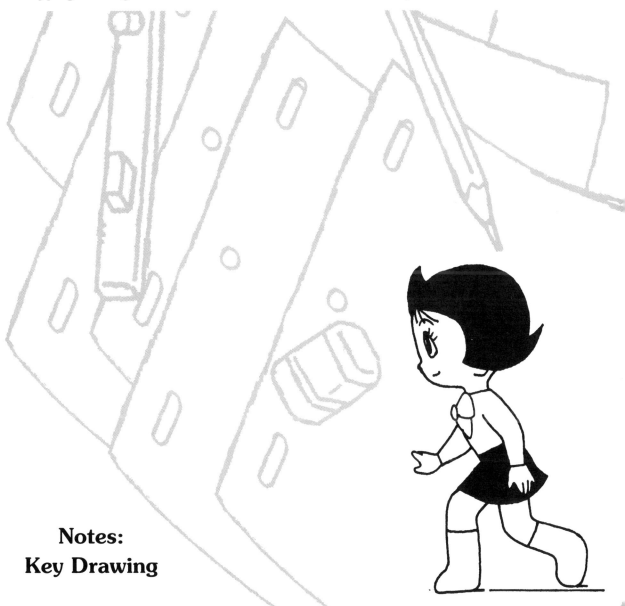

Notes:
Key Drawing

Flip Animation Sample
- Figure Running -
Flip the drawings to see animated movement!

• Look closely at another sample of flip animation taken from pg.36, fig.58. Flip the next few following pages back and forth to see how the human body is moving while this figure is running.

• Get into the practice of drawing simple shapes and general figures. Once you are comfortable with that, you can move on to more detailed characters.

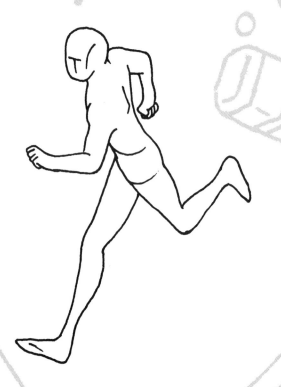

Notes:
Key Drawing

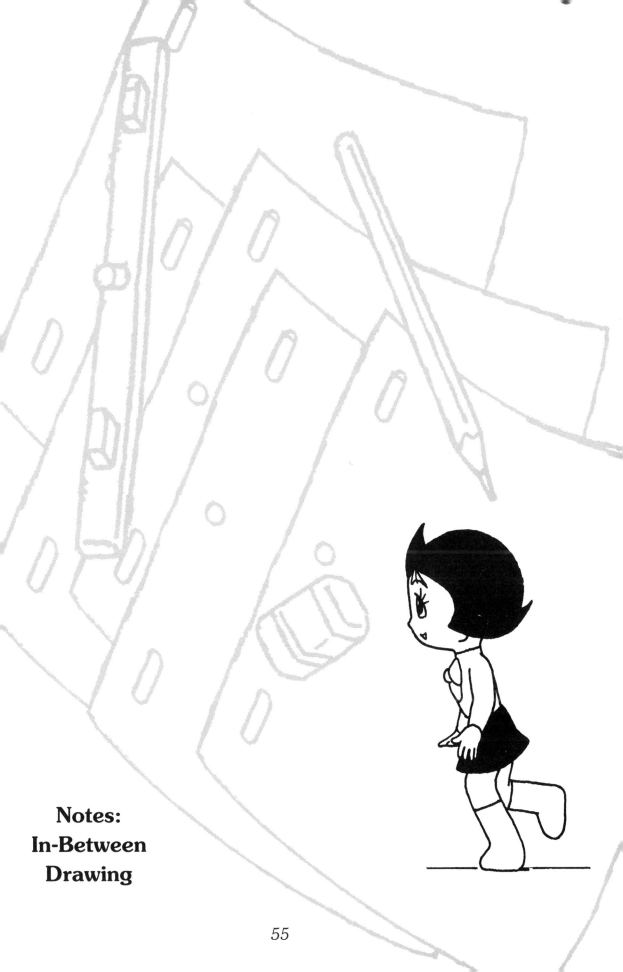

**Notes:
In-Between
Drawing**

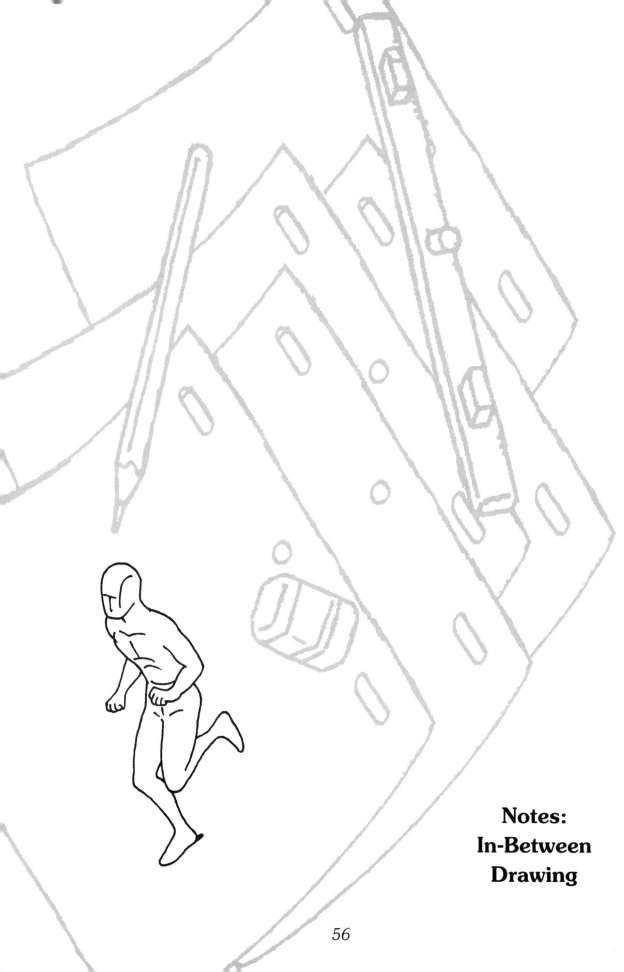

**Notes:
In-Between
Drawing**

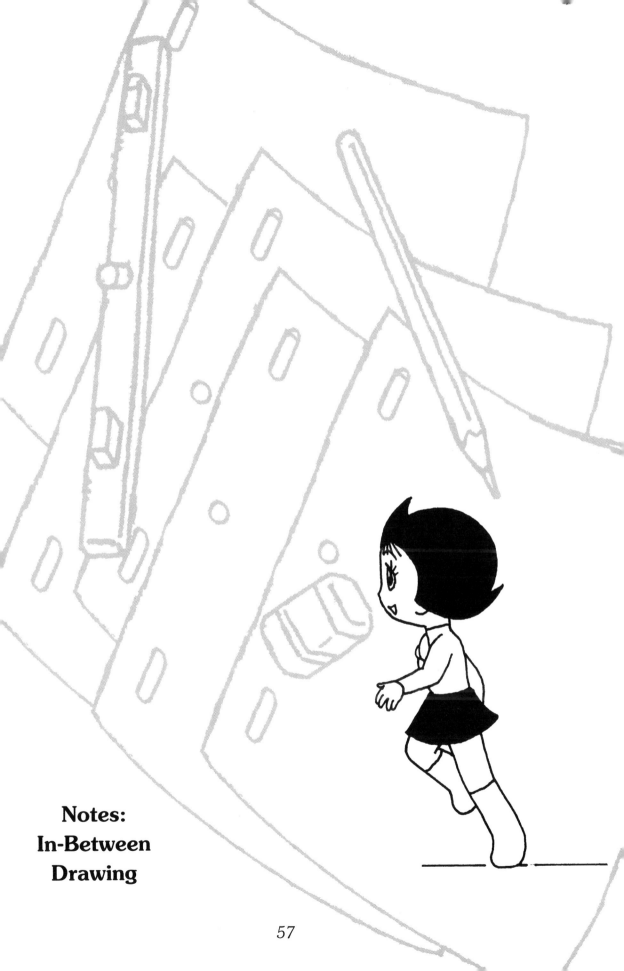

**Notes:
In-Between
Drawing**

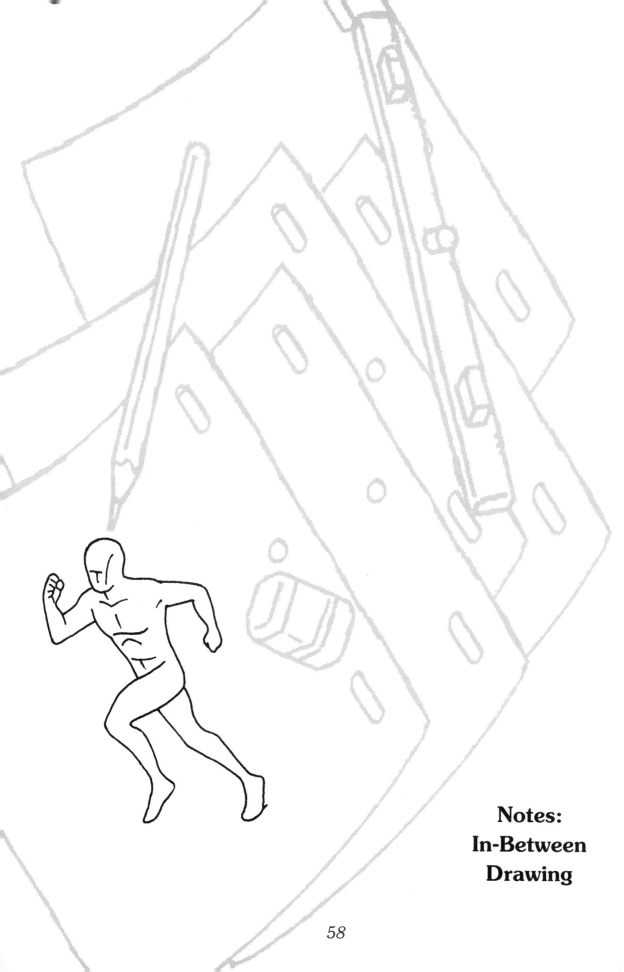

Notes:
In-Between
Drawing

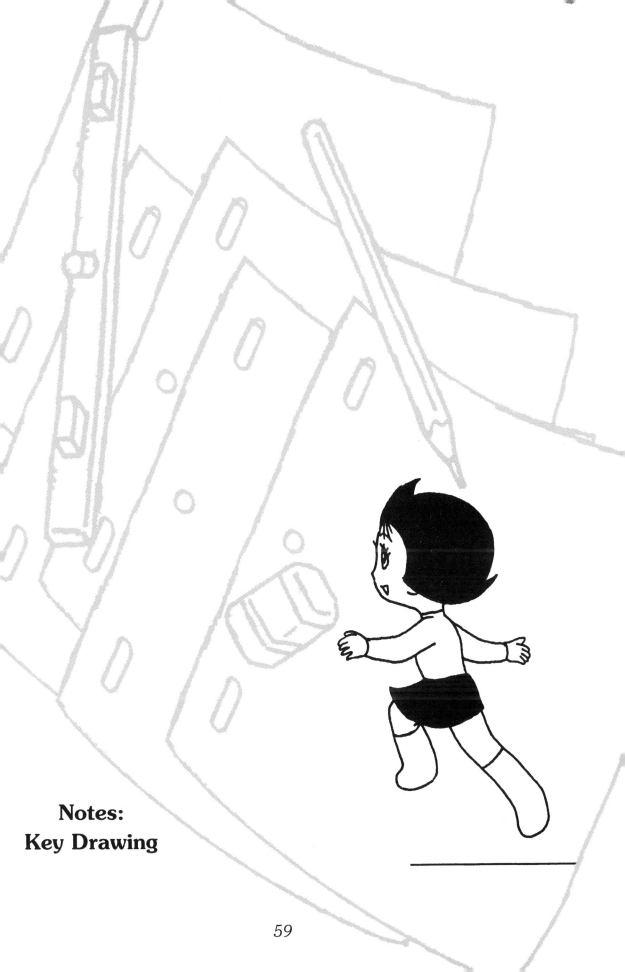

Notes:
Key Drawing

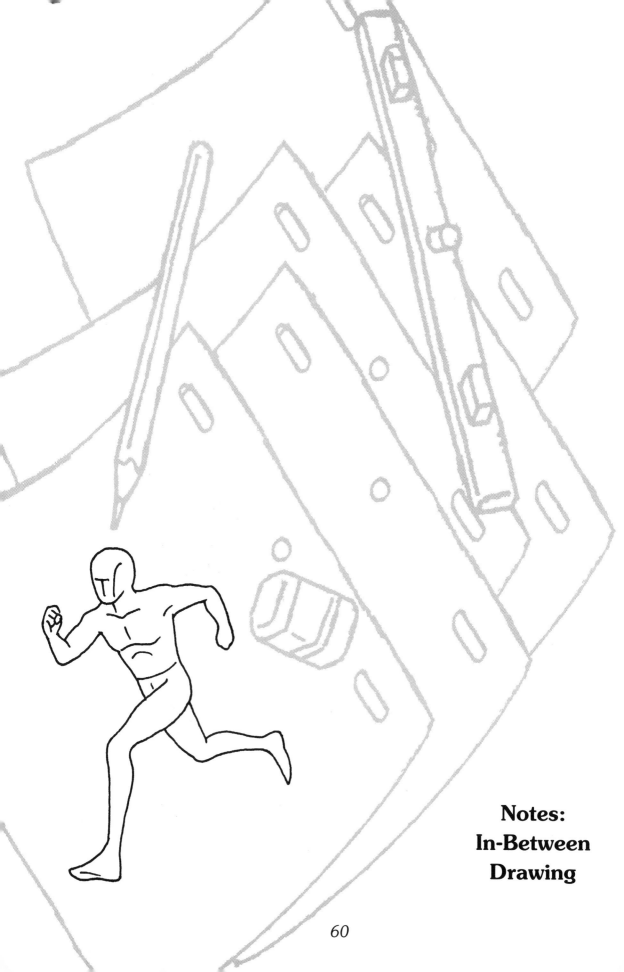

**Notes:
In-Between
Drawing**

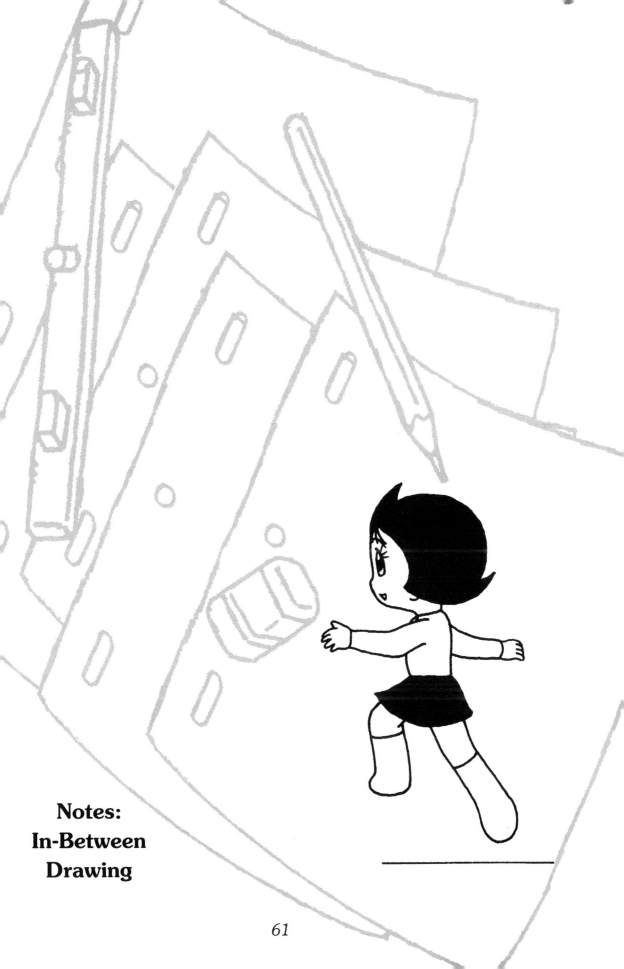

**Notes:
In-Between
Drawing**

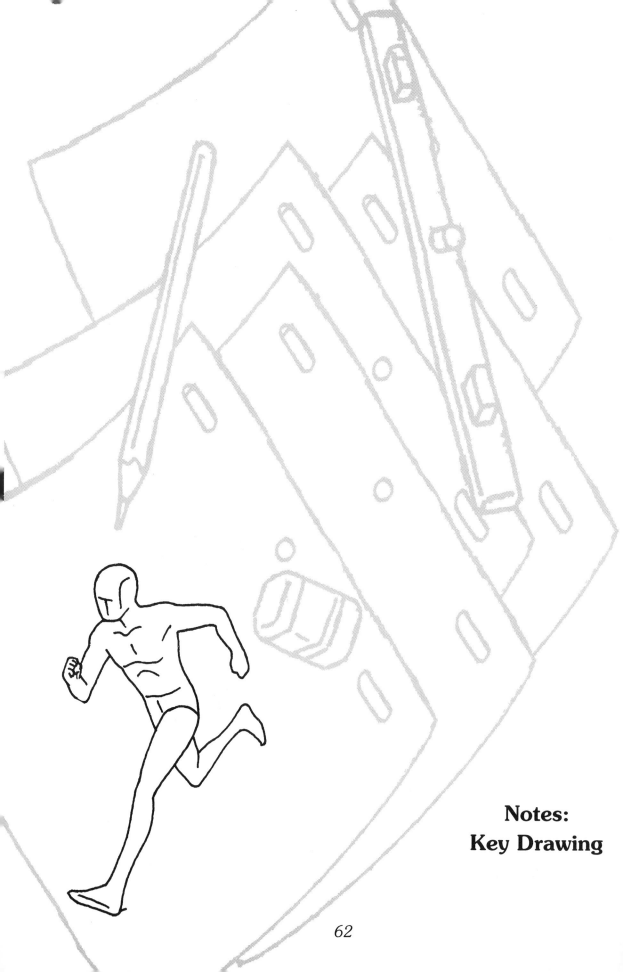

Notes:
Key Drawing

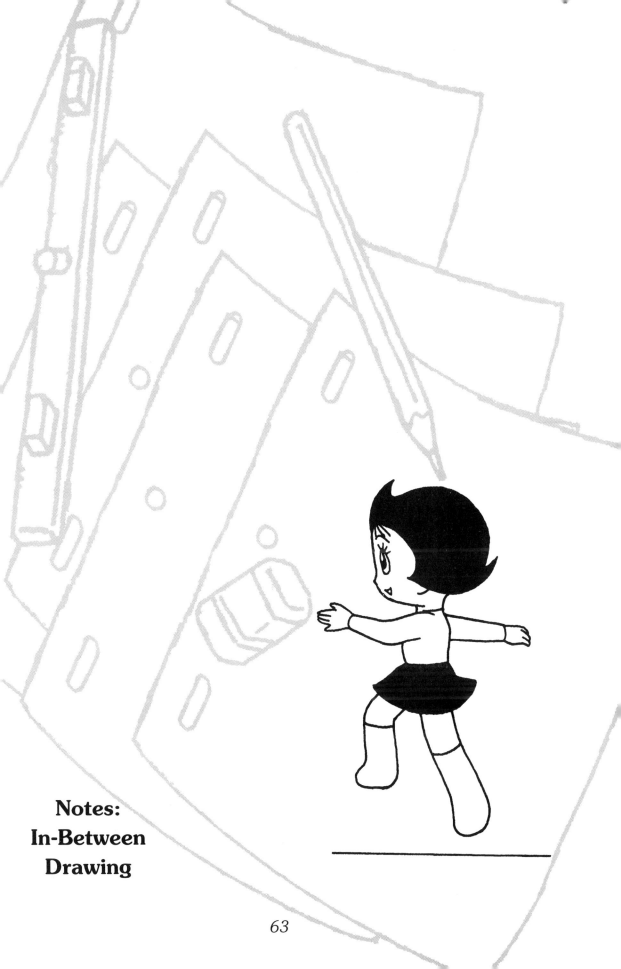

**Notes:
In-Between
Drawing**

63

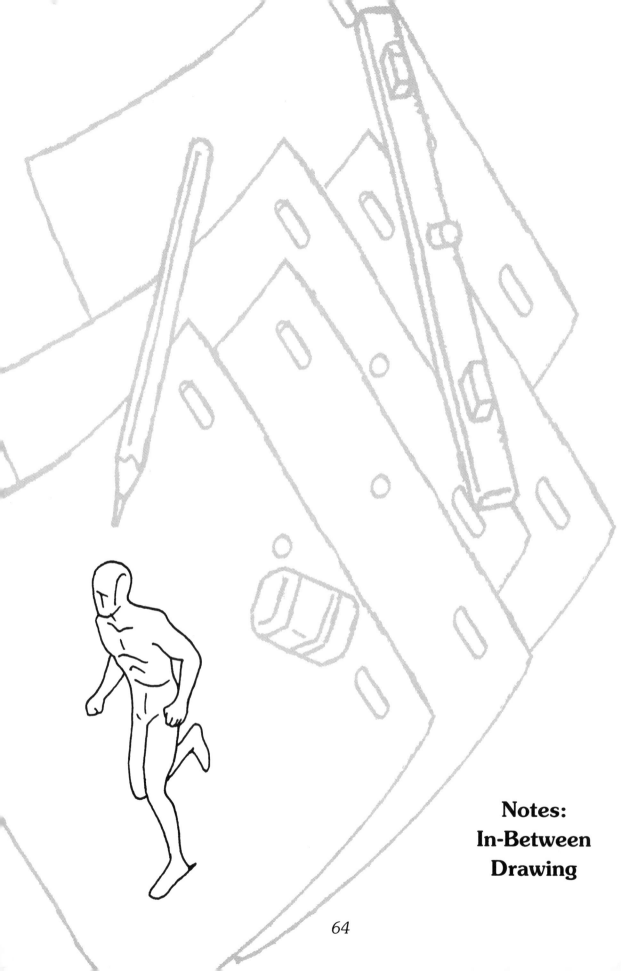

**Notes:
In-Between
Drawing**

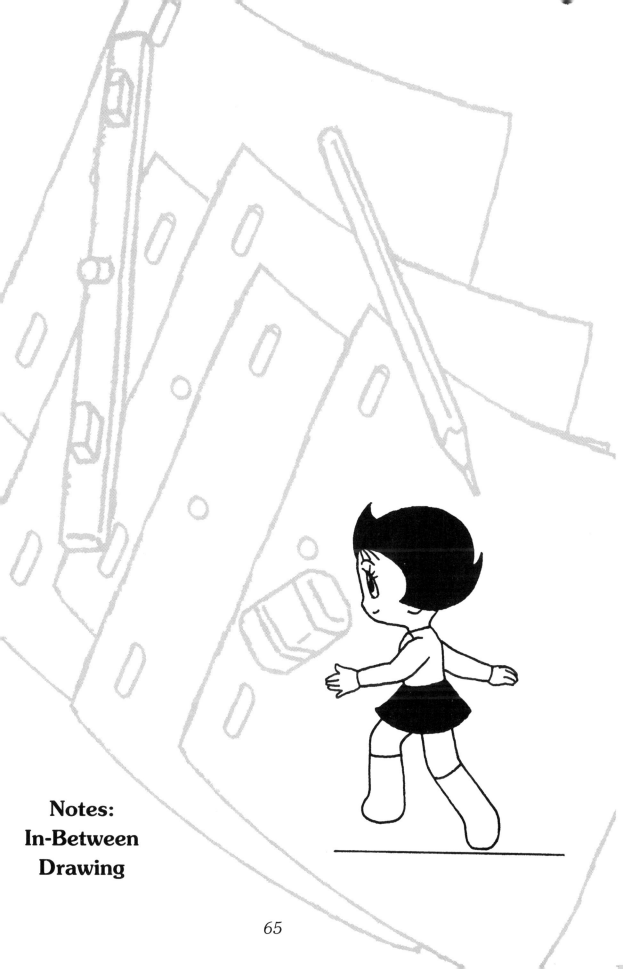

**Notes:
In-Between
Drawing**

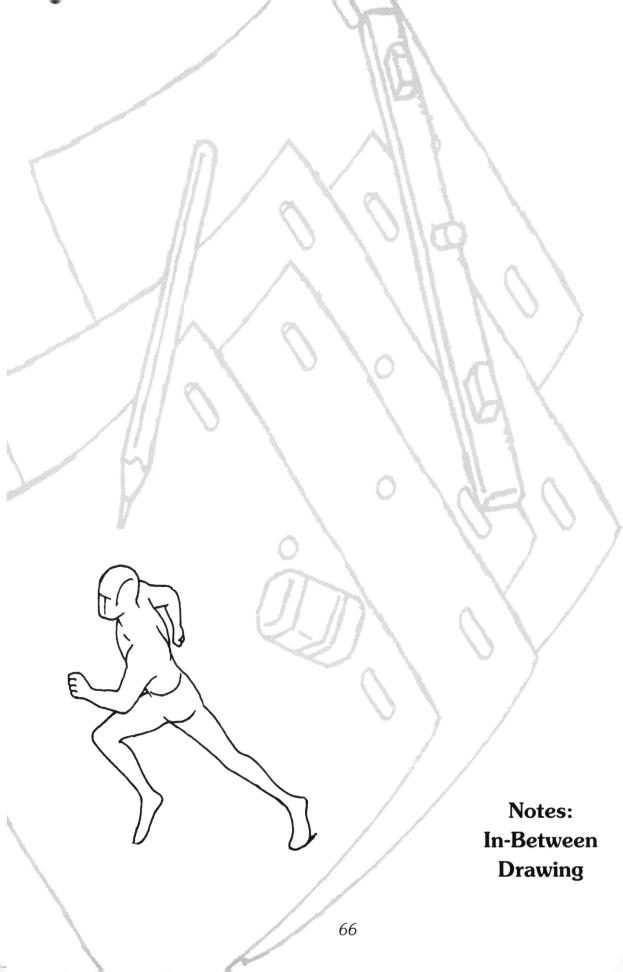

**Notes:
In-Between
Drawing**

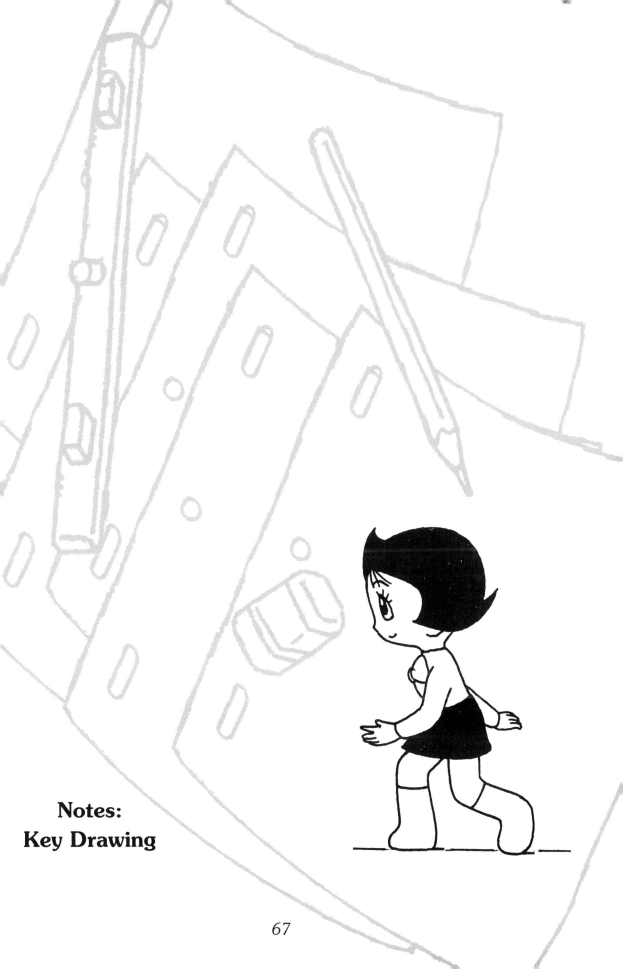

Notes:
Key Drawing

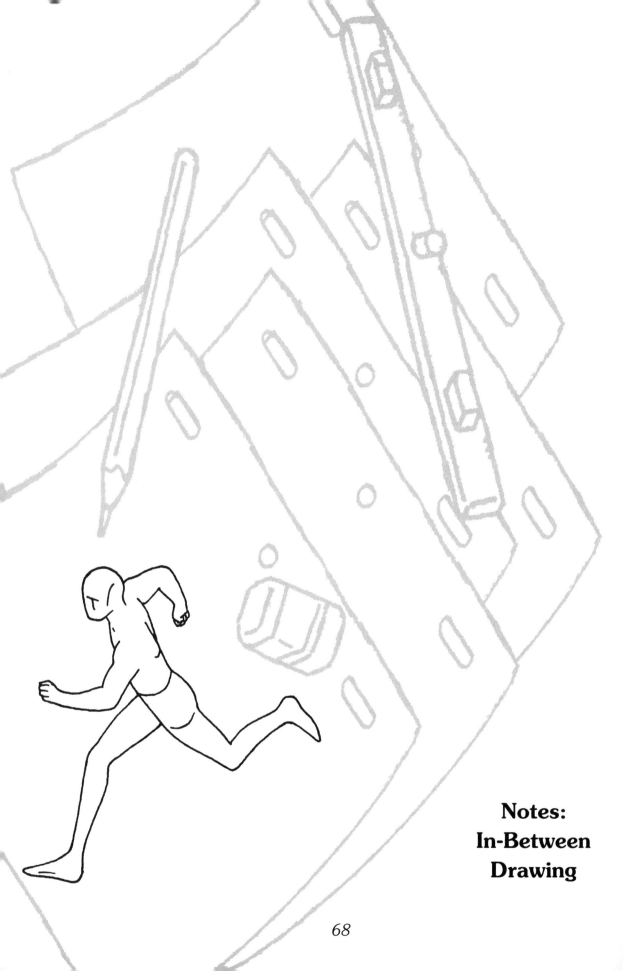

**Notes:
In-Between
Drawing**

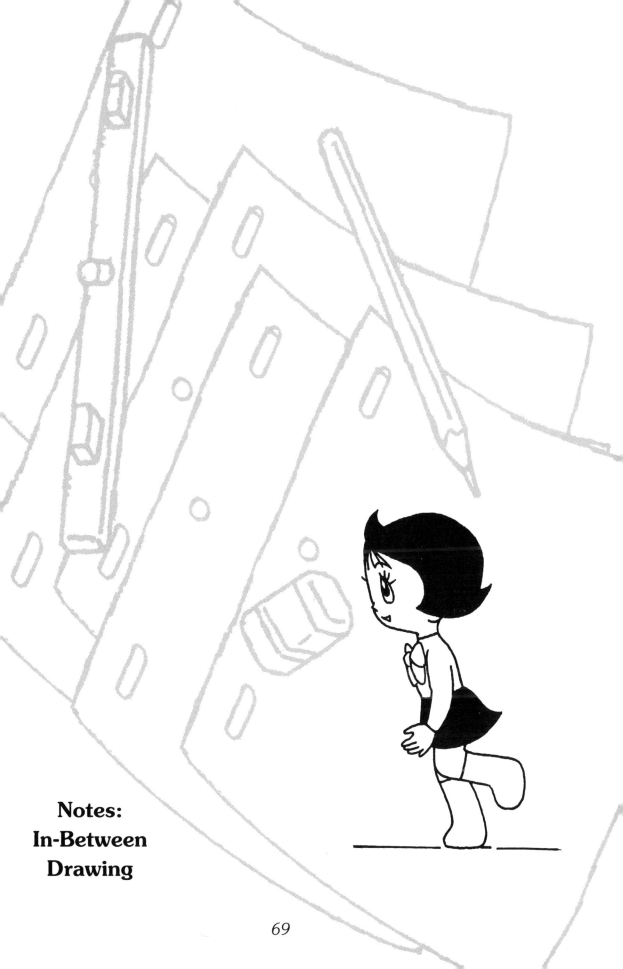

Notes:
In-Between
Drawing

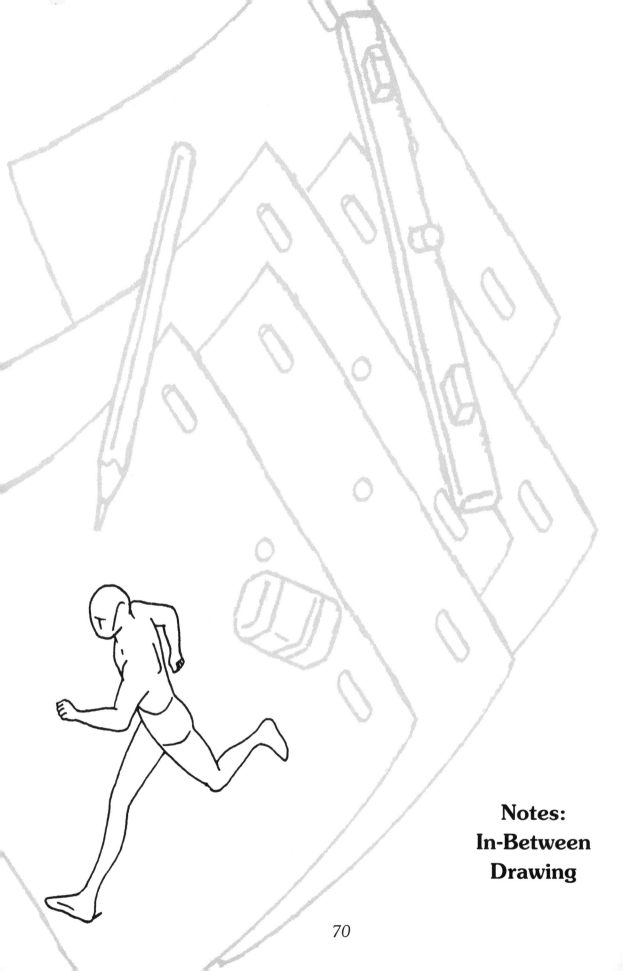

**Notes:
In-Between
Drawing**

Notes:
In-Between
Drawing

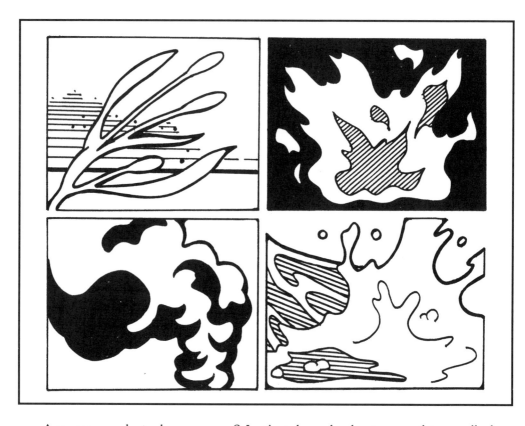

Are you ready to learn more? Let's take a look at something called
Effects and Natural Phenomena.

Chapter 3

Effects & Natural Phenomena
Drawing with:
Fluidity & Flow
Form
Texture
Timing

Hope you enjoyed the flip animation section. Let's move on and learn the fundamentals of another important element in animation: Effects and Natural Phenomena.

An overall concept generally used for effects is the idea of "flow."

Most effects you can think of, such as fire, smoke, water, wind and rain, would not be possible without "flow."

So, how do water, flame and smoke actually move?

Effects
- Flow -

Figure 85 Smoke emerging from a chimney

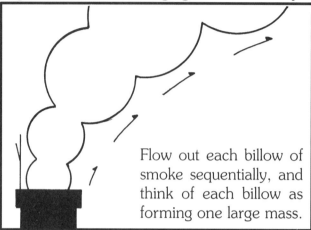

Flow out each billow of smoke sequentially, and think of each billow as forming one large mass.

Basic flow

• Let's use the example to the lef of smoke coming out of a chimne to explain this principle.

• This kind of movement is depicted by using a fixed pattern, which i then repeated.

Figure 86 Flowing out a column of smoke sequentially

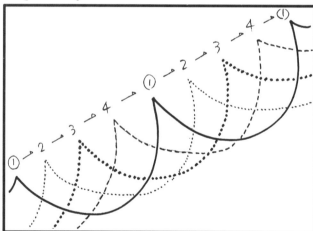

• Think of one billow of smoke as a single pattern, with three intermediate positions per billow. Flow it out as in the above pattern.

• (1) → 2 → 3 → (4) → (1)
Break down the three positions a equally-spaced intervals.

Figure 87 Realistic portrayal

For reference, it's also very beneficial to observe actual smoke.

• In this way, by flowing out the repeating patterns, one by one you can create smoke movement.

• If you make the repeating patterr and its design more complex, you can depict smoke that is even more realistic.

Effects
- Flame -

Fire occurs when an object reaches its ignition temperature, causing molecular decomposition, which produces a gas that burns. The flame moves constantly upwards, rising on hot air currents.

The speed of the flame's ascent slows as it goes higher, with the tips of the flame constantly splitting, breaking off, and then continuing to rise. There sure are many complex movements involved.

Figure 88 The pattern of a moving flame

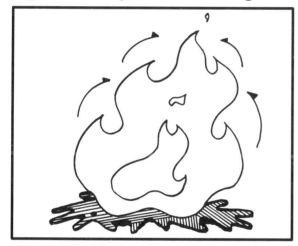

Figure 89 Flowing out a pillar of flame, sequentially

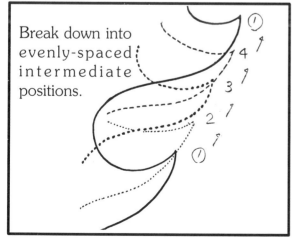

Break down into evenly-spaced intermediate positions.

• In most animation, a pillar of flame is generally created through the repetition of a fixed pattern.

• In this case, the concept of "flow" is also applied.

• Like the flame in Figure 89, flow out the pillar of flame sequentially from the bottom, one 'wave' at a time, as you would with smoke.

• If you create this kind of repetition cycle, you'll be able to make a patterned flame movement.

• These are the fundamentals of flame movement, so make sure to learn them well.

• Let's try to draw a slightly more realistic flame. Due t
interference from the surrounding air, which has a low
temperature, the tongues of the flame split, break of
ascend, and finally extinguish themselves (as if vanishin
into thin air). Let's take a look at the flame's series o
movements as it splits off.

Figure 90 Movement of flame as it splits

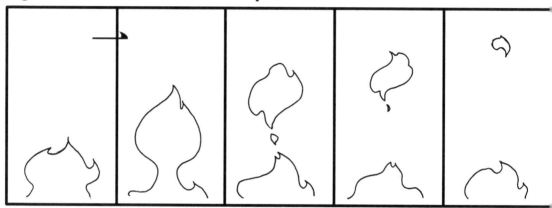

• When drawing a flame splitting off, try making an ellipse with a gentle S-
shaped curve.

• Flame-splitting is made up of the following cycle:

• So, when you animate fire, you basically flow out the flame from the bottom, mo
ing upwards. But in reality, that's not the only way flame moves. There are po
tions that may not burn completely or materials that are reluctant to burn; or ther
may be times when the flame falls to the side, or suddenly burns out.

Animating flame is basically the same in most cases, but differs according to the ature and size of the object that is burning. Animating a candle flame, a kindling ame, or a blaze requires different approaches.

The larger a fire becomes, the more complex its movement and form become. It may ε necessary for the length of the repetition to continue for tens of drawings.

For kindling flame and torch flame, a repetition cycle of six to eight drawings is common.

Make sure that the final product looks, as little as possible, like a repetition is being sed in the movement.

To do so, the picture should give the impression that all eight drawings are uniform o that the style is consistent). If there's one drawing that stands out, you'd be able to ll that it's a repetition.

igure 91

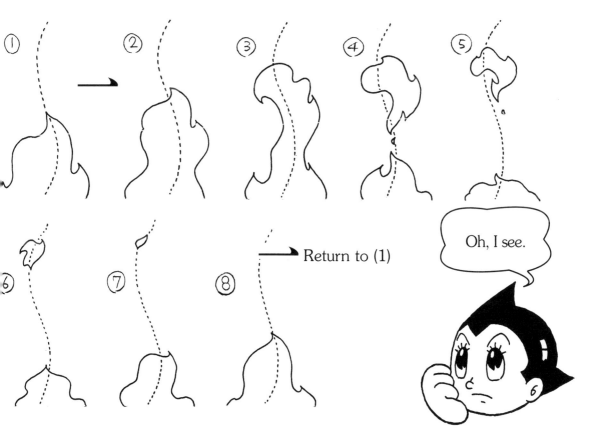

We have explained the repetition of flame in general, but what about drawing a slight more elaborate simulation of flame?

Figure 92 Intricate flame

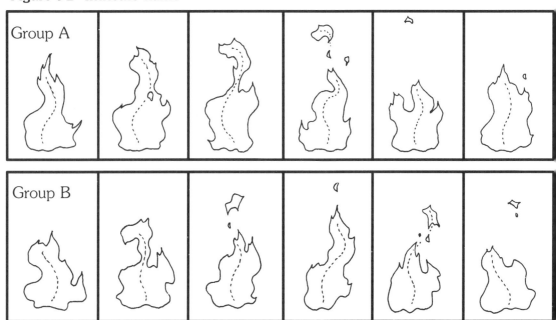

• In order to create the repetition of a more intricate blaze, please refer to the two types of cycles above. By combining A-A-B-A-B-B on the exposure sheet, it will become a more complex movement. Be sure to make a smooth transition when moving from (A) to (B). If you think of (A) as the basic cycle, then (B) is the "custom" cycle. If you make additional custom cycles, like a (C) and a (D), you'll really be able to create flame that doesn't look like it's merely repeating.

Figure 93 Flame design

Even though the basic form is the same, by adding a core to the fire or by putting in other stylistic touches, you can come up with all different kinds of flames.

Effects
- Water -

In animation, when drawing water, it's necessary to be familiar with the qualities of liquid and water. You have to accurately convey its smooth cohesiveness and fluidity. You also need to naturally evoke the sense of an irregular form that is always changing. You may think that anyone can draw water, but conveying its water-like essence realistically is not easy.

Figure 94 Water leaking from a faucet

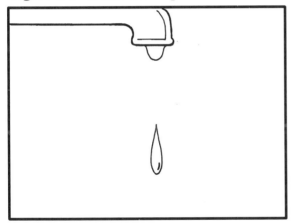

Water that builds up in a faucet, will split off at a certain point (when the surface tension has reached its limit), due to its own weight, to gravity, and to the air pressure, becoming a droplet (also due to surface tension) and then falling down.

If you actually observe when the droplet falls, you'll see how fast it moves.

Figure 95 Drawing of water, bad example

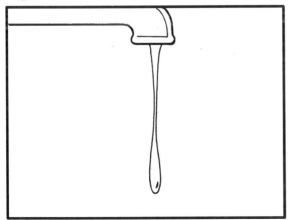

The drawing in Figure 95 does not look like water. This drawing looks more like another material, such as oil, or something with stronger viscosity. Make sure that it really looks like water when you draw it.

When you drop a pebble on the surface of water, the water splashes, and creates a water column. The water column finally becomes a ripple and then disappears. Let's study the mechanics of this movement cycle in order to gain a further understanding of the attributes of water.

Figure 96 Movement of water when a pebble falls on its surface

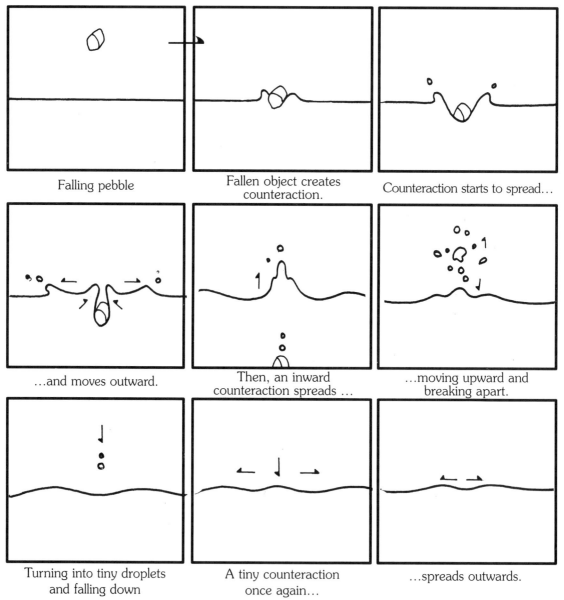

Falling pebble	Fallen object creates counteraction.	Counteraction starts to spread…
…and moves outward.	Then, an inward counteraction spreads …	…moving upward and breaking apart.
Turning into tiny droplets and falling down	A tiny counteraction once again…	…spreads outwards.

When drawing water, it's necessary to understand water's liquid nature. Even when a large object drops into water, the resulting movement should be based on the figure above.

n this page, we illustrate a specific example of water movement, as shown in Figure 97.

gure 97 Pebble falling into water

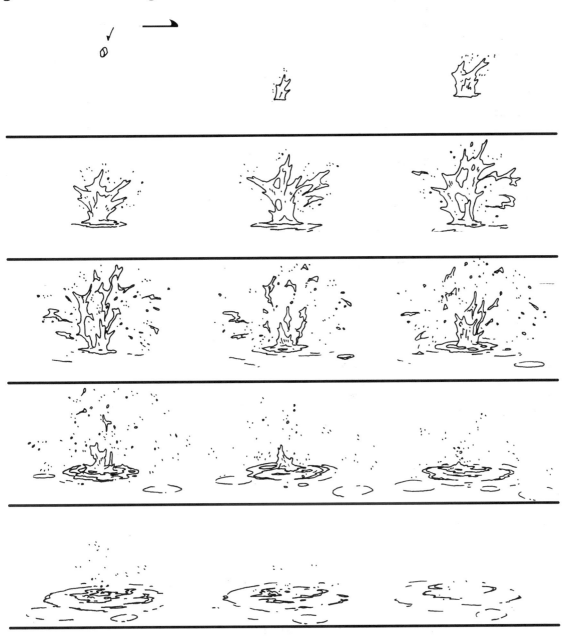

t first, a splash occurs when the pebble falls, and a water column results as a counter-
ction. Depending on the angle of the falling object, the splash and water column may
ccur at roughly the same time.

Figure 98 Animating reflections (from the shore)

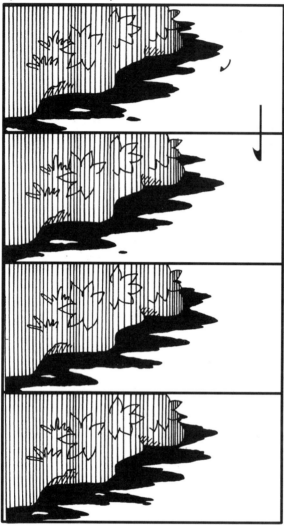

There are various ways to convey the movement of the surface of the water. Here are a number of specific techniques.

(1) Animating reflections (from the shore)

To convey water at the shoreline, Figure 98 shows moving shadows that are reflections from land.

The reflected shapes move gradually downward, depicting a gentle current of water.

Or, when there is no current, as in ponds or lakes, you can flicker the reflections in place without flowing them out.

Either of these patterns can be repeated.

Figure 99 Showing reflected sunlight

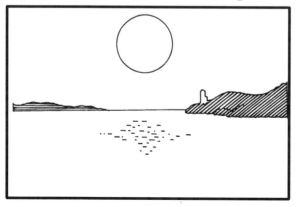

(2) Animating reflected sunlight.

Figure 99 depicts the water surface using the reflected sunlight.

Stylistically, it is common to use transparent light, drawing it in so that it glitters randomly.

Figure 100 Showing reflected sunlight

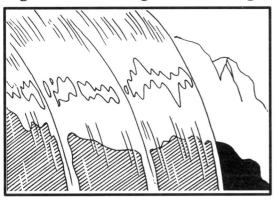

Figure 100 shows how to convey the transparent quality of water. Flicker the part where the reflected light hits the strongest.

The water itself should be a solid color shot in double exposure, leaving the scenery within the water still visible.

Draw white foam on the surface of the water to depict water realistically. Conveying the flowing quality of water through foam alone is an exercise that requires much skill.

Foam occurs when the water contains air and becomes frothy, appearing white.

Figure 101 Animating white foam

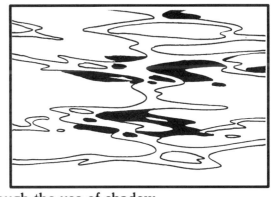

Figure 102 Depicting light through the use of shadow

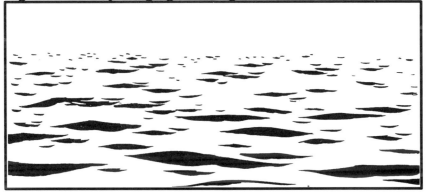

In all things, where there is light there is shadow. Another way to convey a sense of movement of the water surface is through the use of shadow. Drawing shadows can also be thought of as drawing in light, since it is the dark water surface that is reflecting light, and not the other way around.

The general technique is to flow out large masses of shadow as they change in appearance.

To put it plainly, there is an endless variety of ways to draw water. The manner of drawing water may vary according to the characters and the style of a work.

Let's take a look at the fundamentals common to all methods of drawing water.

Figure 103 Variations in pattern **Figure 104 Remains the same**

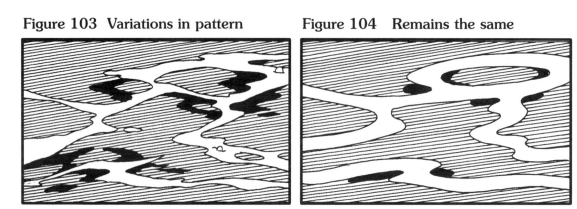

Figures 103 and 104 depict the same body of water. Figure 103 shows fluctuations in the foam and in the overall appearance, and the shadows also vary. In comparison, Figure 104 has an unchanging and mechanical appearance, and the foam has a thread like look. You may see the style in Figure 104 in certain works, but it's pretty obvious at a glance which is the more realistic of the two.

Figure 105

For example, you should probably draw effects such as waves differently depending on whether your work contains cartoonish characters with 2:1 proportions or more realistic and dramatic characters with 8:1 proportions.

Figure 106

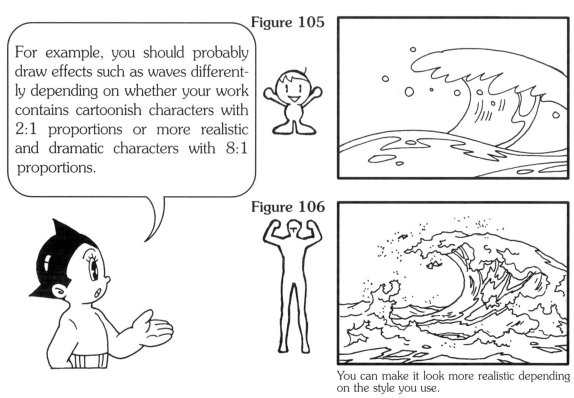

You can make it look more realistic depending on the style you use.

84

Figure 107 Wave motion

Figure 108 Swells hitting and crashing against a sea bank

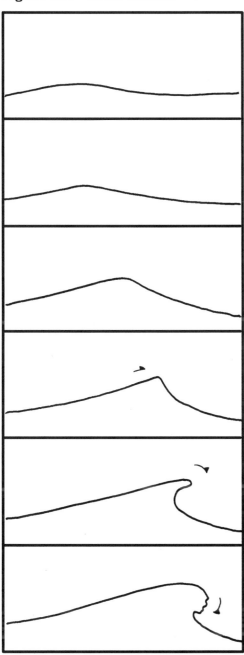

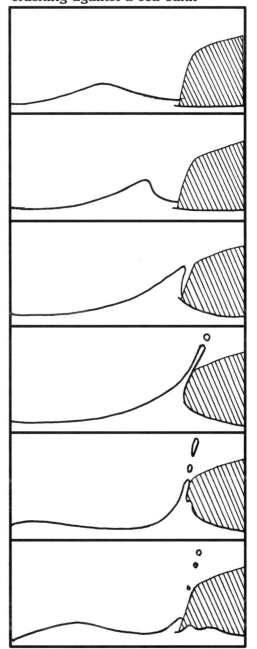

As the swell gets bigger, it generates whitecaps, then goes on to finally engulf its own whitecaps.

Waves hitting a sea bank (or barrier) try to continue moving but ultimately collapse. And a new wave comes along soon after.

You won't be able to depict a certain degree of realism unless you are well-acquainte with the movement and properties of water. It requires much effort and the timing ca be difficult to grasp, so this is a good way to test your chops.

As an example, illustrated below are the main aspects of the movement of a raging sea

Figure 109 A raging sea

In Figure 109, drawings (1) to (4) are all key positions. Between each one, about fiv to seven positions would have to be added.

When you draw the middle positions you have to calculate what goes where, and how it connects to the whole, being aware of how the body of water continues to change

Figure 110 Simplified image of a waterfall basin

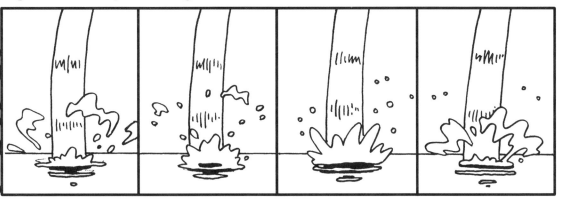

The movement of water in a waterfall basin (1) splashes (2) diffuses creating foam and mixing with air) (3) and disperses (at the surface tension limit),turning into spray and falling down.

This cycle repeats without interruption. Figure 110 illustrates this principle in a very simple manner.

Figure 111 A more realistic waterfall basin

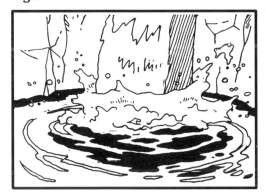

Figure 111 depicts a style with a repetition cycle of about eight to ten drawings.

As a rule:
• The amount of splashing water should always be the same.

• Make sure as much as possible that it doesn't look like it's repeating.

Figure 112 Spray

This is what it looks like when spray droplets are dispersed. Even after becoming separate droplets, try to think of them as a single lump.

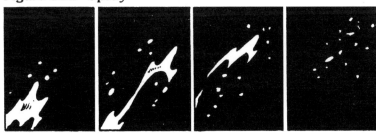

> What are the specific techniques for making inbetween drawings for water?

Water is a liquid that moves according to a fixed principle. Its form is not constant and it continues to alter. How do you depict something like water, with these kinds of properties?

Figure 113 Flowing out water while altering it

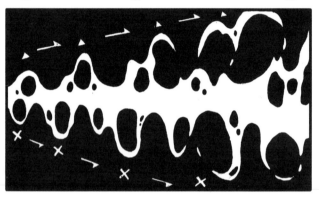

Figure 113 shows foam in th trail of a boat that has passe along the surface of the water.

The shape continues to chang as the boat trail extends, losing i form and finally disappearin completely.

Figure 114 Flowing out and changing shape simultaneously (1)

By flowing out and chang ing the shape at the sam time, you can convey water-like quality.

Figure 114 is a concre example of this.

Figure 115 Flowing out and changing shape simultaneously (2)

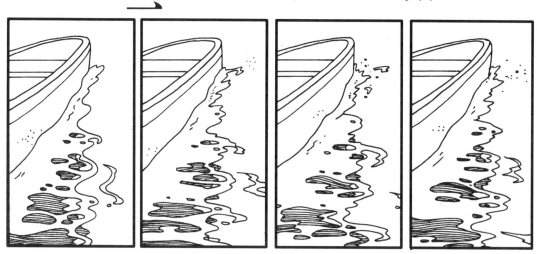

Here's a slightly exaggerated illustration of a boat generating wake. While the shadows from the boat itself flicker, they are flowed out and continue to change shape as they move behind.

Figure 116 Flowing out and changing shape simultaneously (3)

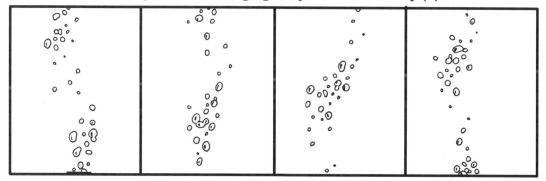

A scene of bubbles rising is also depicted through repetition, and the techniques of flow and shape-changing should also be employed. Bubbles are not only circular, but actually they can also be flat or oval-shaped, and sometimes two or three of them are temporarily stuck together.

**Figure 117
Rain flowing
down a glass
window**

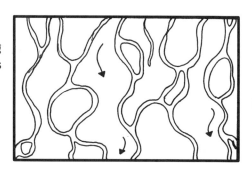

For rainwater streaming down a window, you can also use flow and shape-changing movement.

Effects
- Wind -

Wind is something you can't see with your eyes, right? So then how do you draw wind? You show it by moving the target object that the wind is blowing.

Let's explain this by using the most readily understood example of a flag.

Figure 118 Triangular flag

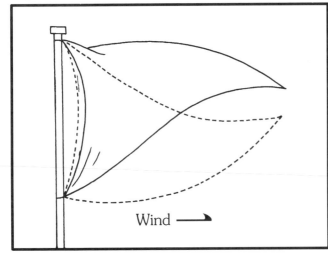

Wind ⟶

Flags

• Flutter the flag (apparent whe the wind picks up and drops off and flow it according to the direction of the wind.

Figure 118 is a simple example of this. You can depict a two-dimensional form using flow, without incorporating three-dimensional flutters.

Figure 119 Rectangular flag

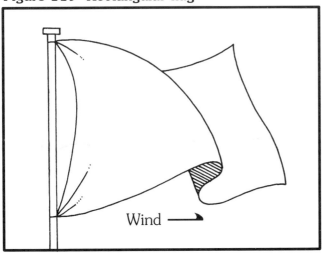

Wind ⟶

• Figure 119 is a slightly more complex example of a flag. It more complicated because of th flowing out of the three-dimensional flutters.

Flags with markings or pictures, o national flags bearing designs are far more difficult.

Figure 120 Movement of flag (triangular)

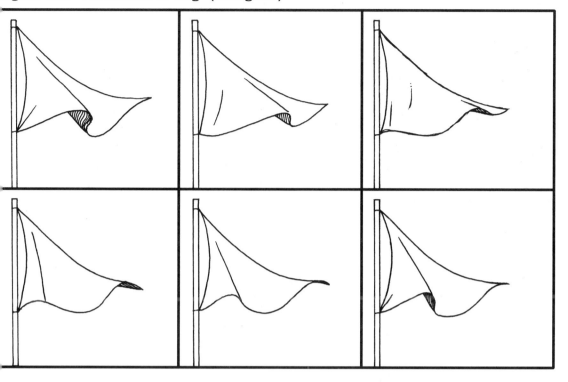

Figure 121 Movement of flag (rectangular)

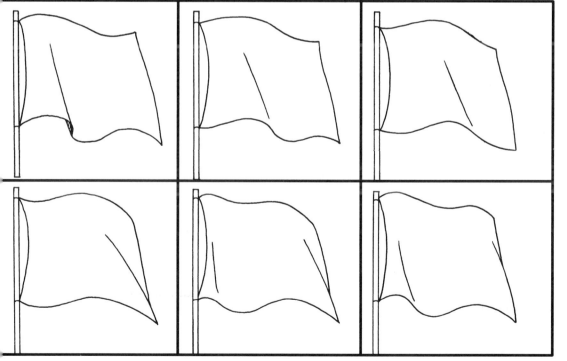

Here's an illustration of the most simple and basic motion.

Figure 122 Cape movement

A fluttering cape is something you see a lot in animation.

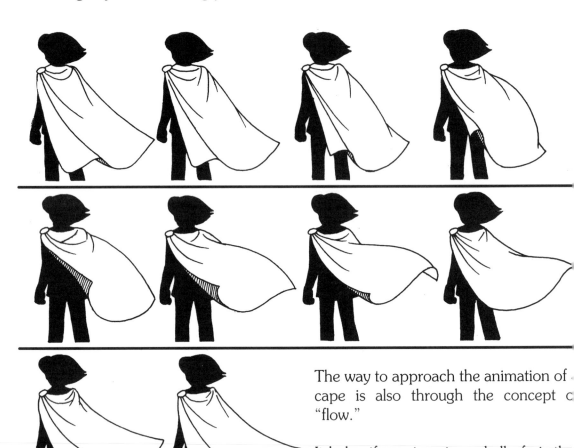

The way to approach the animation of a cape is also through the concept of "flow."

It helps if you imagine a ball of air that swells up the cape and moves around inside it.

**Figure 123
Cape movement**

Flow out the edges of the cape only. It gives a more realistic touch when a cape swells with air.

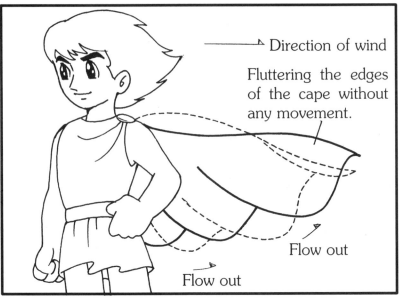

Direction of wind

Fluttering the edges of the cape without any movement.

Flow out

Flow out

Figure 124 A violet fluttering in the wind

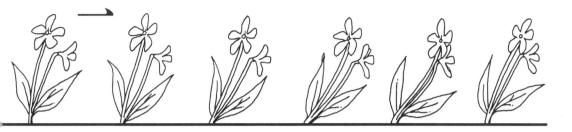

Figure 125 Vibration of fluttering flower **Figure 126 A "delayed" inbetween**

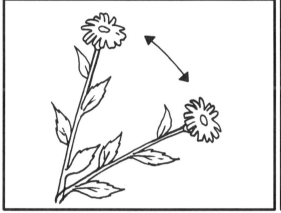
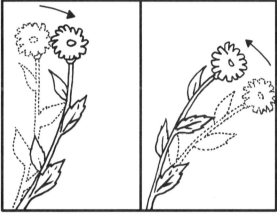

The movement of a flower fluttering in the wind is basically a vibrating motion that uses the base as a fulcrum.

Vibration is not merely a back and forth motion. It has to demonstrate the flexibility and lightness of the flower. How do you add that touch?

If you want to make it more realistic, slightly stagger the timing of the movement of the stem, the petals, and the leaves.

The movement will look more natural if you make use of "delay" for flowers and leaves, as in Figure 125.

Figure 127 Staggering the timing in contrast to the stem

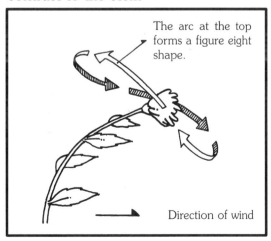

The arc at the top forms a figure eight shape.

Direction of wind

The effect of the wind can be more clearly shown according to the angle of the flutter and the length of the delay.

Figure 128 Grass swaying in the wind and fluttering with staggered timing

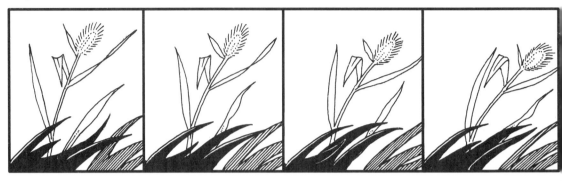

As in Figure 128, when drawing grass in the foreground and foxtails in the background the manner and speed in which they sway may differ. Because the conditions of the wind may fluctuate, it is important to vary the timing, not only for the wind, but for all effects.

Figure 129 A large tree rustled by the wind

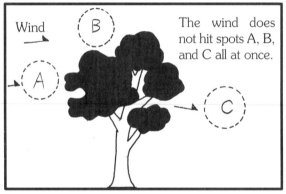

Wind

B

The wind does not hit spots A, B, and C all at once.

A

C

When drawing a large tree rustled by the wind, the timing should generally be staggered, as is the case with grass and flowers.

There may be fluctuations in the power of the wind, and indeed, there may be no wind at all just feets away. It adds a nice touch if you skillfully shift between the tree in its orginal position and the tree as it is moved by the wind.

Figure 130 Rustling that is slightly staggered

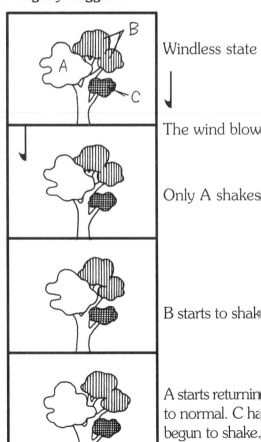

Windless state

The wind blow

Only A shakes

B starts to shak

A starts returnin to normal. C ha begun to shake.

Fluttering of the hair is probably the effect that appears most often in animation.

Figure 131 Good example of hair fluttering

Figure 132 Bad example of hair fluttering

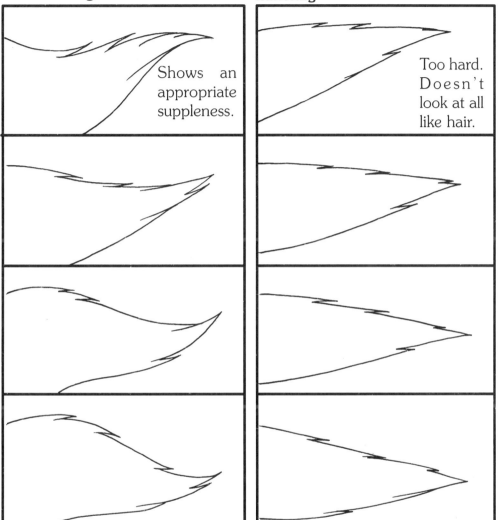

Shows an appropriate suppleness.

Too hard. Doesn't look at all like hair.

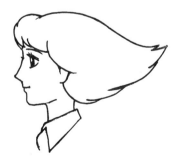

• When drawing fluttering hair, it doesn't look at all realistic when there is a stiffness to the quality and movement of the hair, as in Figure 132.

• Hair is soft, fine, and light. In animation, you have to demonstrate the feel of hair through image and movement.

• Many thousands of fine hairs gather naturally into several clumps. It can be effective if you subtly vary the appearance and thickness of those clumps.

Always make sure the amount of hair appears uniform.

Figure 133 Fluttering of bangs

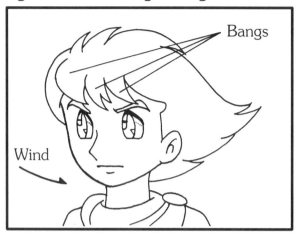

Bangs

Wind

- In general, bangs should move in gentle manner, in comparison to th rest of the hair.

- If you have the bangs moving a much as the rest of the hair, th image of the character may chang entirely. In most cases, in animatior the facial expression of the characte should take precedence over every thing else.

Figure 134 Bangs have an oscillating movement.

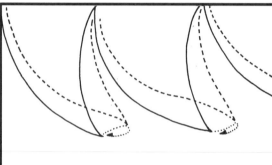

- Basically, the movement of bangs i conveyed with an oscillating motion. is important to incorporate a sligh delay, to convey a lightness and softnes (In some dramatic works, the bangs ar intentionally not moved at all).

Figure 135 Change in number of clumps due to disheveled hair

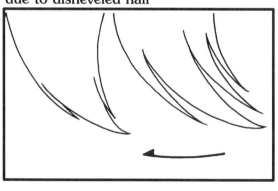

Figure 136 Disheveled hair with inbetween

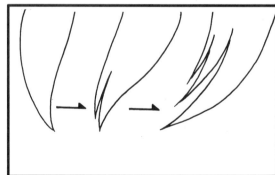

When drawing fluttering hair, the hair will often get disheveled and the number c clumps will change. In such cases, break down the clumps with a few inbetweens at time, in even intervals. Overall, conveying a realistic sense of hair requires a highl refined sensitivity and technique.

Effects
- Smoke -

Smoke is also one of the more important effects. There are many different types of smoke, from the thin kind that dissolves into the air, like cigarette smoke, to smoke that carries a sense of weight, like smoke from a fire or volcano. Each of them is drawn in its own manner and has its own style of movement.

Figure 137 Cigarette smoke (Type A)

Figure 138 Cigarette smoke (Type B)

Figure 139 Type A drawn realistically

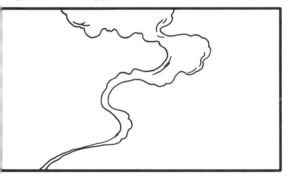

• Figure 137 shows cartoonish cigarette smoke. For this type of smoke, you can animate it with a simple "flow."

• In Figure 139, the movement becomes a bit more realistic, and a simple "flow" will not suffice.

Figure 140 Large cloud of smoke

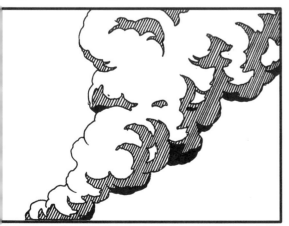

A large cloud of smoke moves powerfully during a volcanic eruption

• When you look at an extensive cloud of smoke from a distance, as in a volcanic eruption, it hardly seems to be moving at all.

• Volcanic smoke gives you a sense of considerable weight and solidity.

• The sense of solidity is suggested by the smoke itself, due to its shadows and overlapping plumes.

Figure 141 Momentary smoke

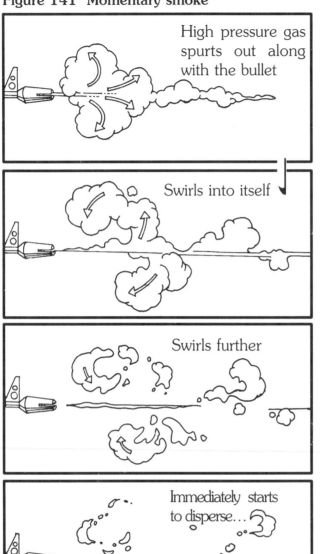

High pressure gas spurts out along with the bullet

Swirls into itself

Swirls further

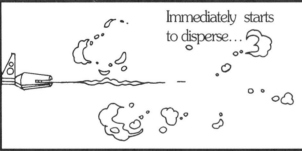

Immediately starts to disperse...

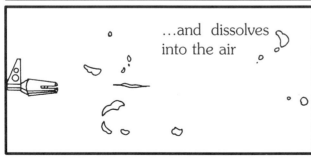

...and dissolves into the air

For drawing smoke, you can use either a tracing pen or a brush.

• Smoke blown out of a gun muzzle is momentarily generated and then gradually disappears.

• For basic animation, make sure that the clumps of smoke roll in on themselves and small clumps then break off.

• Be careful to incorporate variations, so that the timing and shapes don't all appear uniform. Make sure that the same images don't repeat---this can be said for all effects.

• At first, it is actually difficult to vary the pictures in an intentionally inconsistent way. (It's easier to make everything uniform).

• In order to create effects skillfully, it's good to observe actual fire, smoke, and water, for reference.

• It's not that the effects have to look as real as if they were photographed, but the distortion should at least be based on the correct principles.

Figure 142 An explosion is a phenomenon of instantaneous ignition and combustion. It is an animation effect that often appears in science fiction or fighting scenes.

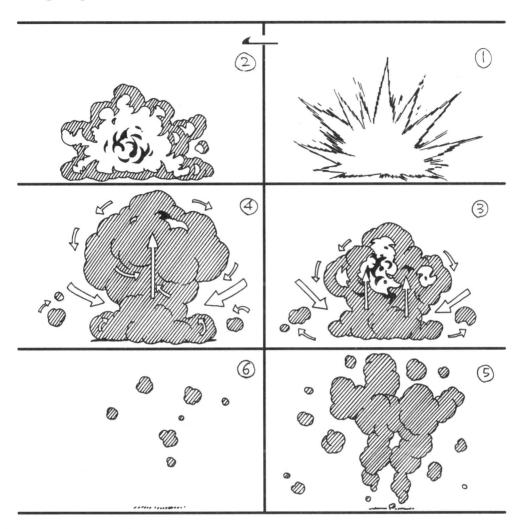

1) Instantaneous combustion

2) The flame and smoke generated expand in all directions momentarily.

3) The flame weakens little by little, and the smoke swirls. The smoke rises due to the heat.

4) Atmospheric pressure gathers at the base of the smoke cloud, which narrows, and as a result forms a mushroom shape.

5) The speed decreases the higher the smoke rises.

6) Little by little, the smoke expands into the surrounding air and starts to dissolve. For the flame in (1) and (2), a transparent color close to white is often used to convey the higher temperature.

Effects
- Lightning -

Lightning is a phenomenon in which an electrical discharge is generated from cumulus clouds. Since the amount of time it shines is extremely short, it is usually shown in animation for about four to eight frames.

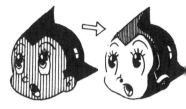

Figure 143 Movement of lightning (thunderbolts) and the appearance of the background

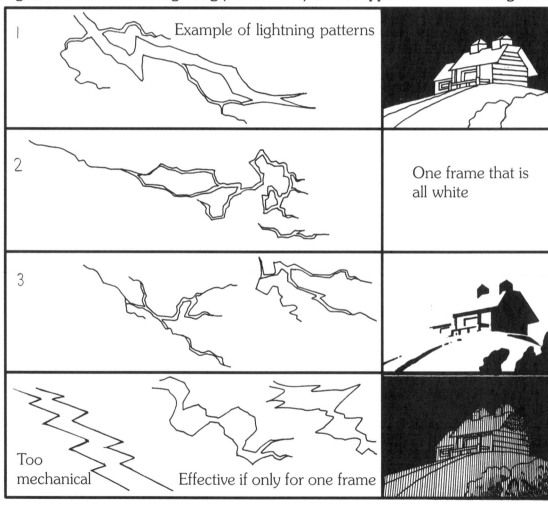

1 Example of lightning patterns

2 One frame that is all white

3

Too mechanical Effective if only for one frame

• In order to make an even stronger impact with lightning scenes, you can use methods such as using three to four different drawings of lightning patterns one after another, or giving a directional movement to the lightning, or making the lightning thicker. Also, when an illuminated background or character returns to normal after being shown in high-contrast, you can have a brief overlap as they return to normal.

Effects
- Rain -

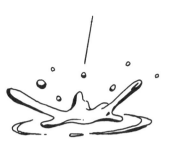

There are various ways to depict rain in animation, such as through drawing alone, through cinematic effects, or through other special filming techniques. Below, let's look at the basic method of animating rain.

Figure 144 Basic rain

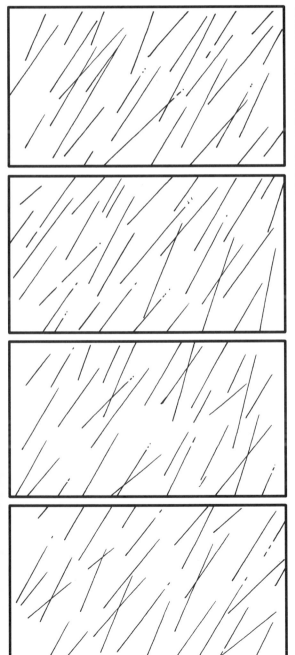

Figure 145 Rain falling to the ground

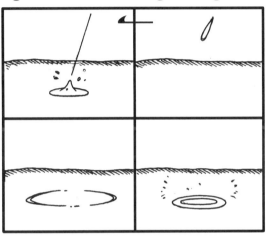

• Recently, it has become the norm to portray rain by drawing three to four pictures and then shooting them at random. This is the method shown in Figure 144.

In this case, make sure that each picture has about the same amount of rain. Shooting should not be confined only to the sequence 1→2→3→4, but should be random, such as 2→4→1→3.

• In Figure 145, rain is falling to the ground.

In this case, when the rain drop strikes the puddle, a ripple results, expanding outward. In general, this repetition should be made frequently, at irregular intervals. In such cases, it's also important to alter the timing of each cycle as well.

Effects
- Snow -

• Snow is the most widespread effect used to convey winter

In animation where snow falls, put the snow on a gentle arc and flow it out it in repetition. This is the most basic way to animate snow.

Figure 146 Basic arc for snow

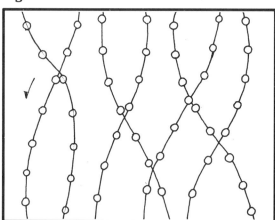

Figure 147 Break down into three inbetweens

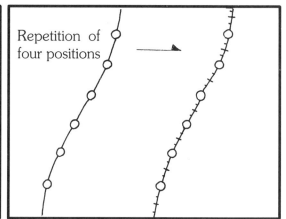

Repetition of four positions

Figure 146 is the most basic way of animating snow and Figure 147 is the way to break it down into inbetweens. Snow's manner of falling should not be too vertical or too curvy. It is most snow-like when a quality of lightness is apparent. Also , if the "flow" speed is too fast, it won't look like snow, so pay attention to the placement or distance of the intervals between each snowflake.

Figure 148 Bad examples

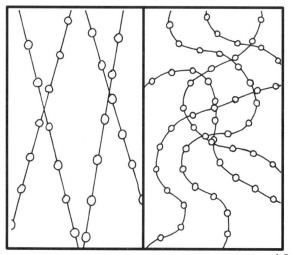

Figure 149 Receding snow

Snow in the background (Cel A) Snow in the foreground (Cel B)

There are times when snow falls very quietly, slowly and heavily. If you want to depict it in this way, you can draw dwindling snow that is receding in the background on an oblong cel.

Effects
- Metamorphosis -

Metamorphosis is another way of saying animated transformation. It used to be the favored technique in animation, but recently, it's not often seen in Japanese animation. It's been replaced by CG in most cases, but if you're able to draw it well, it can still be a very effective and fun animation touch!

Figure 150 Basic metamorphosis (gradually transforming with each inbetween)

Figure 151 Metamorphosis after temporarily turning into other shapes (reaction transformation)

• Figure 150 is the style most often used, in which the shape of the character gradually transforms and finally becomes a different shape. Specifically, it can often be seen in such scenarios as a magic battle in which object A is animated and transformed into object B.

• In Figure 151, there's no gradual transformation of each inbetween, but instead, each picture turns into something completely unexpected. It can be a lot of fun, and if well-done, it will surprise people who see it.

• In the past, this type of metamorphosis was used abundantly in famous scenes in such films as Toei's *Journey to the West*, Disney's *The Sword in the Stone*, and Tezuka Productions' *Hi No Tori 2772*.

Figure 152 The following examples are for reference: a flower metamorphoses into Japanese writing and then into English letters; Rukio (the lion cub from *Kimba the White Lion*) turns to a butterfly, and Songoku (a character from many Chinese fables) transforms into a chair.

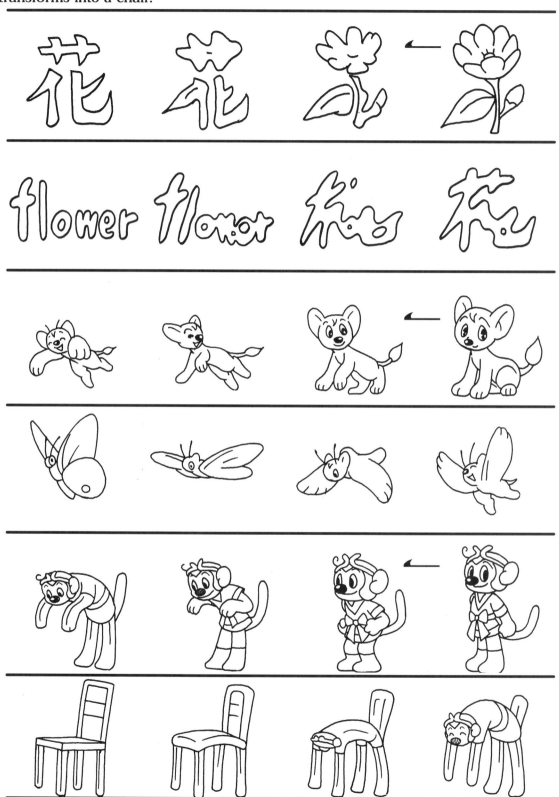

Background Animation
- Special Animation Effects -

Background animation means what it says literally, namely animating the background. The group of buildings around me as I fly through this city is an example of an animated background. There are times when everything in the picture is moving. But in this case, the main animation is the scenery. If background animation is well-done, you can create a powerful and splendid sense of actually being there.

Figure 153 Side-view diagram

Figure 154 Background with perspective

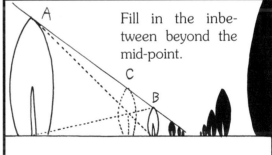

Fill in the inbetween beyond the mid-point.

For background animation, the background usually doesn't have to be drawn nontop, but is animated through "repetition" cycles of about four to ten drawings. Background animation that keeps on changing for a certain number of seconds can be dramatic, but for commercial animation, the number of drawings or frames is limited due to various limitations.

Figure 154 is a background animation of a row of trees. If it's a repetition cycle of even drawings, position C would be in the middle in terms of distance and would be drawing number four. Figure 153 is a diagram of the same thing seen directly from the side. Usually, for perspective drawings, like Figure 154, you should only fill in one inbetween for each interval. If you add numerous inbetweens for each interval, it will surely look strange.

THE FORCE BEHIND TEZUKA PRODUCTIONS

Heralded by many as the **"Father of Manga," Dr. Osamu Tezuka** was one of Japan's most prolific and beloved manga artists. Born in 1928, Tezuka grew up loving stories, especially those depicted in manga and the early animated films of Disney. A student of medicine, Dr. Tezuka received his degree from Osaka University in 1946, however, while still in school, Tezuka found that being a manga artist was more to his liking. His first published work debuted that same year. Over the course of his life, Tezuka drew over 170,000 pages of manga.

Tezuka is probably best known as the creator of the animated series *Astroboy* (*Tetsuwan Atom* in Japan), which was the first animated series to ever be broadcast on TV in Japan. Tezuka created over 60 animated series and films, including *Amazing Three*, *Princess Knight* and *Kimba the White Lion* (which many say was the inspiration for the *Lion King*). Tezuka died in 1989, but his legacy lives on through his company, Tezuka Productions.

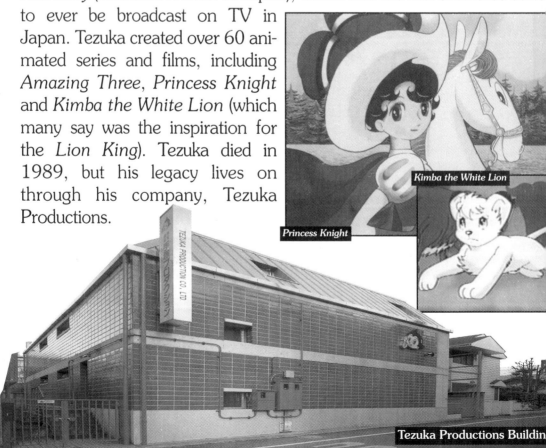

Kimba the White Lion

Princess Knight

Tezuka Productions Buildin